IMAGES
of America

EARLY DARTMOUTH COLLEGE
AND DOWNTOWN HANOVER

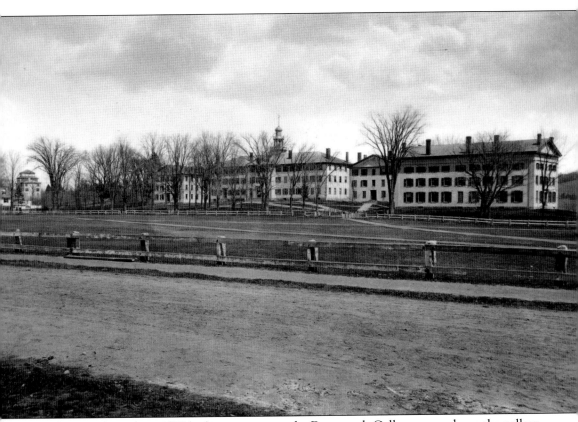

This view from about 1870 looking east across the Dartmouth College green shows the college, which, for much of the 19th century, was a small, regional school of about 300 students. Unlike many vistas of the college and village area, this view is entirely recognizable today. (Dartmouth College Special Collections.)

On the cover: Shown from left to right, the three Tanzi brothers, Leon, Charles, and Harry, with Charles's wife, Harriett, pose for a photograph in front of the Tanzi Brothers grocery store in 1949. For 72 years, from 1897 until its closing on June 30, 1969, the store was very much the center of life on the Main Street of Hanover—in many ways where the village and the college really came together. (Dartmouth College Special Collections.)

IMAGES
of America

EARLY DARTMOUTH COLLEGE AND DOWNTOWN HANOVER

Frank J. Barrett Jr.

ARCADIA
PUBLISHING

Copyright © 2008 by Frank J. Barrett Jr.
ISBN 978-0-7385-5655-0

Published by Arcadia Publishing
Charleston SC, Chicago IL, Portsmouth NH, San Francisco CA

Printed in the United States of America

Library of Congress Catalog Card Number: 2007942107

For all general information contact Arcadia Publishing at:
Telephone 843-853-2070
Fax 843-853-0044
E-mail sales@arcadiapublishing.com
For customer service and orders:
Toll-Free 1-888-313-2665

Visit us on the Internet at www.arcadiapublishing.com

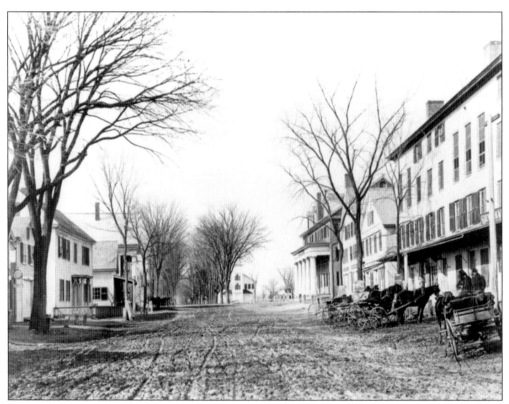

Unrecognizable today, this 1870 view looking north up South Main Street toward the Dartmouth College green shows the Tontine block at the immediate right and just beyond is the front colonnade of the Dartmouth Hotel. In the far distance is the Church of Christ at Dartmouth College, now the site of the Baker Library complex. (Author's collection.)

CONTENTS

ACKNOWLEDGMENTS

Dartmouth College and the village area that was an integral part of the institution from the start were fortunate that, since the early days of photography, images of it were made, recording its special history. I have been fortunate to collect illustrative remnants of its history over a period of more then four decades. However, for this project, my archives alone were not sufficient.

First, the fine staff at Dartmouth College's Rauner Special Collections Library deserves acknowledgment, praise, and thanks for their always professional, courteous, and knowledgeable assistance with many of the historic images used in this book.

Second, there were many individuals who were gracious in providing me with important historic information about past Hanover family members and friends, and in several cases, they provided an image to further help tell this story.

Finally, I must acknowledge my maternal grandmother, affectionately known to us as "Nanny," for giving me, when I was only about nine years old, a handful of dusty, old postcards of Dartmouth and Hanover that were postmarked in 1908. Her gift, recognition, and support of my early interest in the history of my hometown sparked further inquiry and the subsequent accumulation of much historical material concerning this special place over the past 45 years.

INTRODUCTION

The autumn of 1760 marked the close of long hostilities between the French and English over which nation would control North America. As a result, it became practical to once again settle in the Upper Connecticut River Valley. By late that year, considerable pressure was being placed upon New Hampshire's royal governor Benning Wentworth to do so. Therefore in March 1761, Wentworth commissioned Joseph Blanchard, a surveyor from Dunstable, to mark off a tier of townships on each side of the Connecticut River from Fort No. 4 in Charlestown—the northerly most point of any settlement—to "the upper end of the great meadows at the Lower Coos," today the towns of Newbury, Vermont, and Haverhill, New Hampshire. Traveling on the late winter ice, Blanchard marked at six-mile intervals a tree on each side of the river, which he numbered for the corner of a future township to be granted. Later that spring in the governor's office in Portsmouth, towns on each side of the river extending from Charlestown to the northern boundary of Haverhill were arbitrarily plotted. On July 4, 1761, in that same office, the governor signed five charters, creating the first new towns in the "western section" of the province since the outbreak of the French and Indian Wars seven years before. Thus Hanover was created, a six-mile square, 22,400-acre tract of dense, forested, virgin wilderness fronting on the Connecticut River. And as he did with every town so created, the governor set aside a 500-acre lot of land for his own personal speculation. On a simple sketch of Hanover that was part of the charter, the very southwest corner of the town was marked "B. W."

From the start, there appeared to be little to distinguish Hanover from any of the other townships being created in the valley along both sides of the river. In fact, it did not possess broad and fertile meadowlands along the river like Haverhill and Newbury nor did it potentially benefit from substantial waterpower like Claremont and Lebanon. However, by early summer of 1765, permanent settlers began to arrive, clearing their land and establishing a meager agricultural basis. Periodically beginning in 1764, portions of the town were divided into 100-acre lots and assigned to proprietors. By early 1770, Hanover boasted 20 families settled about the town in a scattered pattern; however, the southwest corner remained untouched and unsettled, including the governor's 500-acre parcel. That was soon to change in a very unique way.

Eleazar Wheelock, who founded the ninth of America's colonial institutions of higher learning that was the last to receive its charter from the crown of England, was born in Windham, Connecticut, on April 22, 1711. A student of theology at Yale College, by 1734, he was pastor of the Second Parish of Lebanon, Connecticut, and soon thereafter became seized by the Great Awakening, a religious revival spreading throughout the Northeast. To augment his family finances, Wheelock began instructing English boys preparing for college, and by 1743, a young

Mohegan Indian named Samson Occom became his first Native American pupil. This proved to be such a great success that other Native Americans followed, and by 1755, Wheelock received a gift of land and buildings adjacent to his home from Col. Joshua More, which Wheelock named More's Indian Charity School—a pioneering enterprise.

Wheelock's vision of a missionary school for Native American and white students was concurrent with the British interest in seeking to spread the gospel in the colonies in order to offset the success of the French Jesuit priests who were bringing Catholicism to the Native Americans. As a result, Wheelock's first thoughts were to expand and relocate his school to the Susquehanna River region in New York or Pennsylvania; however, the costs and complications of doing so by the early 1760s caused him to instead turn his attentions to the Upper Connecticut River Valley, possibly in New Hampshire. By 1764, Wheelock and those close to him came to see the potential of raising substantial funds in England and Scotland for this new school. Therefore, from 1766 until their return in 1768, Wheelock's close confidant Rev. Nathaniel Whitaker and star Native American pupil Occom traveled through England and Scotland preaching the gospel and raising funds. Among the most prominent benefactors were the second Earl of Dartmouth William Legge, London merchant John Thornton, and King George III.

With money in hand, Wheelock once again turned his attention to the matter of relocating his school, and by April 1769, he chose New Hampshire, although he did not have a charter until December of that year.

Almost immediately upon receiving his charter from John Wentworth, who in 1767 had replaced his uncle Benning as royal governor, numerous towns within the Upper Connecticut River Valley began competing for the new school's favor, hoping for its establishment within their borders. Landaff, Orford, Piermont, Bath, and Haverhill all expressed interest, with Haverhill the strongest contender. By late January 1770, Hanover, too, decided to enter the fray, although by then it appeared that Haverhill was destined to be the new location. However, Wheelock was told that Hanover was "settled with the most serious, steady inhabitants." In a letter dated March 13, 1770, it was pointed out to Wheelock that in addition to generous gifts of land totaling as much as 3,000 acres, Hanover was near "a very narrow place in the great river for a bridge; and it is by a long pair of falls, where salt and other articles brought up the river will be cheaper then . . . further up."

After Wheelock and an inspection party visited many of the proposed locations, including three days looking at the wilderness site in Hanover for the first time on about June 8, 1770, it was officially decided to relocate to Hanover on July 5, 1770. There was no settlement nearer than across the river in Norwich, so the party stayed there at Capt. Jacob Burton's inn.

In August 1770 at age 59, Wheelock arrived in Hanover with 30 to 50 men to start clearing land to establish his new school, now called Dartmouth College. In addition to the governor's initial gift to Wheelock of his uncle Benning's 500-acre tract of land, adjacent parcels totaling more than 1,300 acres were soon added to the college's holdings.

Almost immediately upon construction of several log huts to temporarily house the college, a village started to grow up around the school. Wheelock reached out to attract trade persons and others that would be necessary for the support of the institution. In many ways, it was independent of the settlement occurring elsewhere in Hanover, and the unique village area was soon referred to as "the Village at the College." Well into the 20th century, as both Dartmouth College and the village around it took hold and grew, the area remained a unique and special place with a story of its own.

One

THE VILLAGE AT
THE COLLEGE

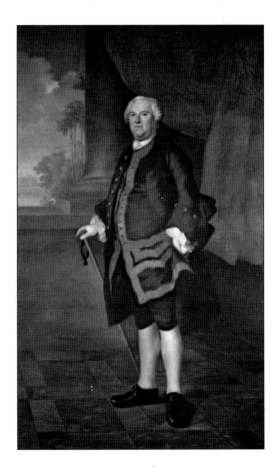

Benning Wentworth (1696–1770) was appointed as royal governor of the colony of New Hampshire in 1741 and served until his removal from office in 1767. Residing in Portsmouth, the colony's capital, he considered all of present-day Vermont as part of New Hampshire. Toward that end, in 1761, he began establishing new towns on both sides of the Connecticut River, including Hanover, which was chartered on July 4, 1761, the same day as the adjacent towns of Norwich, Hartford, Lebanon, and Enfield. (Dartmouth College Special Collections.)

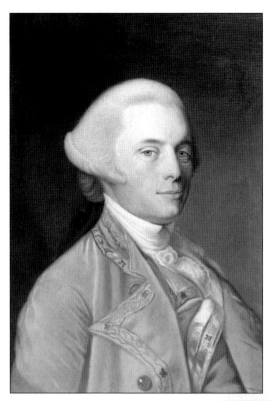

John Wentworth (1737–1820) was appointed royal governor in 1767 after his uncle Benning Wentworth fell from favor with King George III. A graduate of Harvard College in 1755, he was a man of culture with a deep interest in education. During the late winter of 1770, he played a crucial role helping to locate Dartmouth College at Hanover. Five years later at the beginning of the American Revolution, he fled New Hampshire as a loyalist and eventually came to be governor of Nova Scotia. (Dartmouth College Special Collections.)

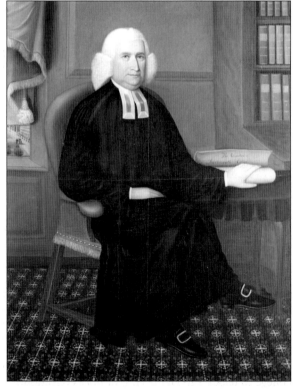

Eleazar Wheelock (1711–1779) was born in Windham, Connecticut, and studied theology at Yale College. As a young pastor in Lebanon, Connecticut, he became heavily influenced by the Great Awakening, led by the Reverends Jonathan Edwards and George Whitefield. It was the evangelist in Wheelock that led him to establish his successful "Lattin School," educating Native Americans in Connecticut. This school later became Dartmouth College in 1769, just before it relocated to Hanover in 1770. (Dartmouth College Special Collections.)

By 1743, Samson Occum (1723–1792) was one of Wheelock's first and most successful Native American pupils. Shortly after, Occum went on to become a noted preacher and schoolmaster to the Montauk tribe on Long Island. Wheelock was so pleased with Occum's impressive success that from 1766 to 1768, Occum, with Wheelock's close confidant Rev. Nathaniel Whitaker, traveled throughout England and Scotland raising funds for a new college that Wheelock had in mind. (Dartmouth College Special Collections.)

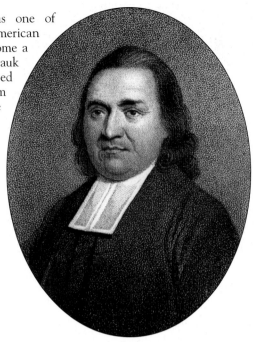

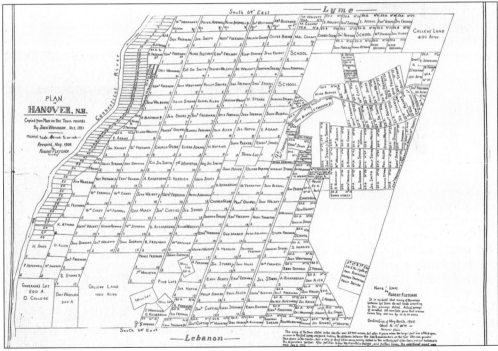

In March 1760, Gov. Benning Wentworth had a surveyor establish the outlines of future towns on both sides of the Connecticut River in unnamed blocks of about six miles square. Within each block, a 500-acre parcel of river land was reserved for the governor. This map illustrates how Hanover eventually came to be lotted. It also shows Wentworth's land in the far southwest corner and two other adjacent large parcels that were used in 1770 to entice Wheelock and his college to relocate to Hanover. (Author's collection.)

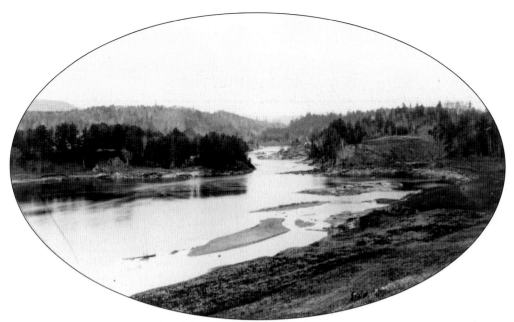

Prior to the construction of Wilder Dam in 1950, there existed the so-called White River Falls about a mile south along the Connecticut River from the Hanover-Lebanon town line. It was where the river dropped almost 40 feet over successive rock ledges. Most early travel in the area was by river, and Eleazar Wheelock understood that being near these falls would save transportation costs and be easier to move provisions, instead of being farther north on the river as first proposed. This early photograph looking up the river at the falls was taken about 1860. (Author's collection.)

Wheelock also understood the potential benefits of locating his new college near a narrow site on the river where a future bridge crossing could be made. In fact, in 1796, the second bridge ever constructed across the entire Connecticut River was erected here between Hanover and Norwich. The first was completed south at Bellows Falls in 1784. This view from about 1875 shows the narrowness of the river and the fourth bridge built at this location. (Dartmouth College Special Collections.)

In the early days, what is now West Wheelock Street was little more then a crude path running up through a steep ravine to "the Village at the College." However, by the time this photograph was taken in 1876, a simple dirt road existed, officially laid out in 1797, threading its way uphill beside a sandy, eroding landscape cut clear of all its virgin white pine trees. (Author's collection.)

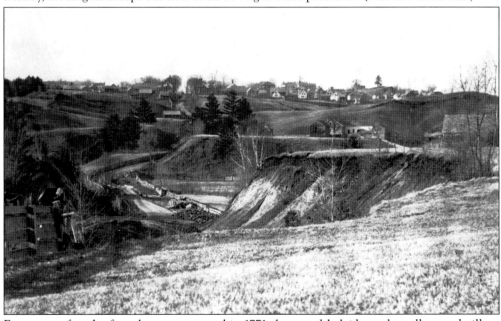

Four years after the first plan was prepared in 1771 that roughly laid out the college and village area, a "highway" was completed that extended south to Mink Brook Meadows and the Lebanon town line. First referred to as Lebanon Road, it later came to be called South Main Street. This early photograph looks northerly about 1867 across Mink Brook up toward the Village at the College. (Author's collection.)

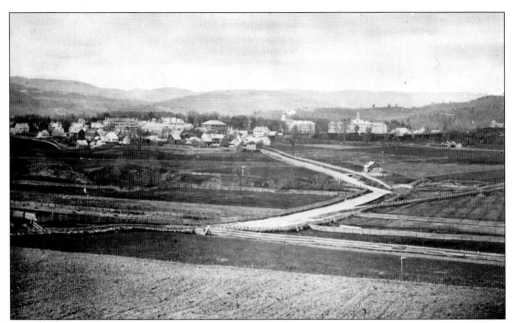

The Village at the College is visible in the distance in this view taken about 1867 looking northwesterly from what was then referred to as Sand Hill, immediately east of present-day Lebanon Street and adjacent to Velvet Rocks. In the right-hand foreground is what is known today as the Crowley Terrace–O'Leary Avenue neighborhood and to the left is the Woodrow Road, Barrymore Road, and Storrs Road neighborhood. (Dartmouth College Special Collections.)

This 1860s photograph looking southeast along Lebanon Street from about the site of the present-day school complex illustrates how barren the landscape around the village had become by relatively early in the 19th century. Clearing for the cultivation of crops, the raising of animal feed, and grazing land had stripped the area of its mature, virgin forests. (Dartmouth College Special Collections.)

H. O. Bly, the first known professional photographer with a studio in Hanover, took this photograph around 1860 looking south from the high rock outcropping of the college park toward the intersection of present-day Park and Lebanon Streets. This image clearly shows the open, somewhat barren agricultural landscape surrounding the Village at the College. (Author's collection.)

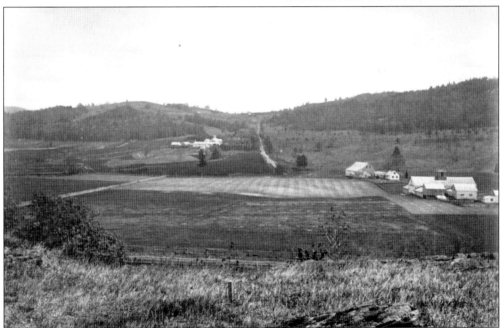

This view from about 1875 looking east from the college park, the present-day site of the Bema, shows mostly open farmland on Balch Hill (left) and Velvet Rocks (right). East Wheelock Street, once called Hanover Street, heads off between the two hills toward Etna Village. In the foreground, immediately below the bluff, is North Park Street. (Author's collection.)

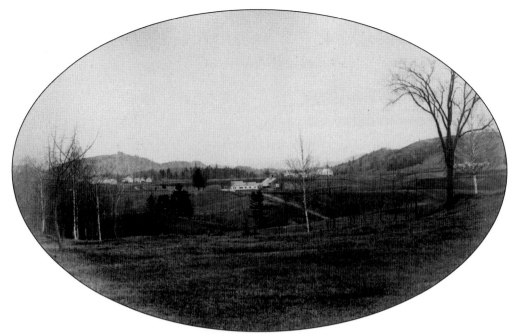

Here is an unusual view from about 1865 looking northwest on Lyme Road from the crest of the hillside adjacent to the Dewey Farm, the present-day site of the Dartmouth Medical School. The first cluster of farm buildings in the distance is still the farmhouse located today at 25 Lyme Road. (Dartmouth College Special Collections.)

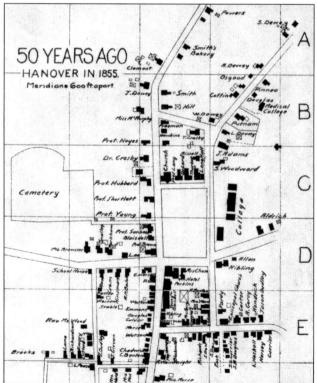

This is a redrawn version of an earlier map of the village and college first published in 1855. The Dartmouth Green is in the center, and north is toward the top of the page. Note that the college basically consists of the four buildings now known as Dartmouth Row plus the observatory up in the college park. (Dartmouth College Special Collections.)

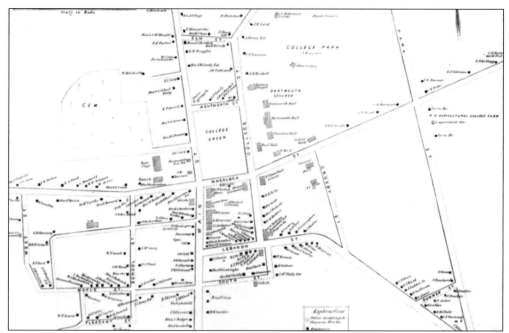

An 1892 map similar to the one on the previous page shows the village area spreading outward as well as the New Hampshire Agricultural College Farm located adjacent to Park Street. For more detail about this interesting period of Dartmouth and Hanover history when the state college was located here, see chapter 2. (Author's collection.)

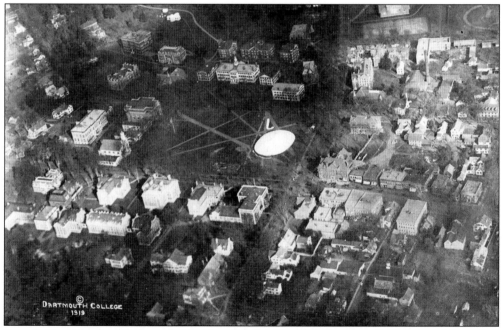

From Friday, October 17, through Monday, October 20, 1919, Dartmouth College celebrated its sesquicentennial, or 150 years since the school's founding in 1769. Shown in the center of this excellent aerial photograph, looking east of the combined campus and downtown village area, is the large, circular tent erected on Dartmouth Green for the event. (Author's collection.)

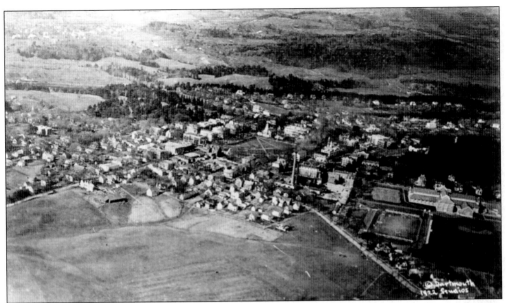

Shown above is another early aerial view that looks north from over Lebanon Street in 1922. At that time, the Village at the College was still compact; however, that was to change, as the pastures visible in the foreground of the old Currier Farm were developed in the 1920s and 1930s. (Author's collection.)

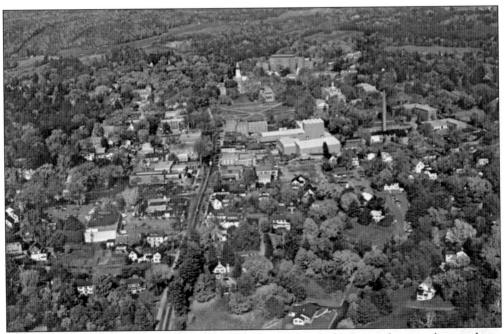

Looking from a position somewhat westerly of the photograph above, this aerial view shows the campus and downtown area 50 years later, about 1972. Clearly visible in both views is the Dartmouth Green and the tall, slender chimney of the college's heating plant. Note the increase in the number of trees in the 1970s view. (Author's collection.)

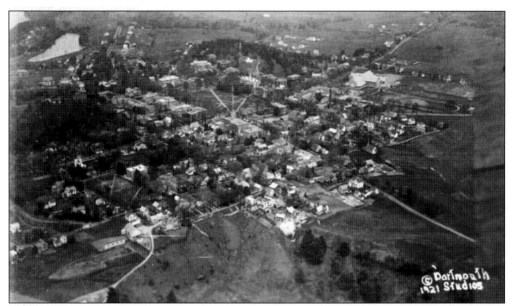

From a vantage point almost over the mouth of Mink Brook, this 1921 aerial view looks northeast toward the village and campus area. In the upper center are the Dartmouth Green and its radiating walks, and in the far upper-left corner is Occum Pond. This view also illustrates the relative flatness of the Hanover plain. (Author's collection.)

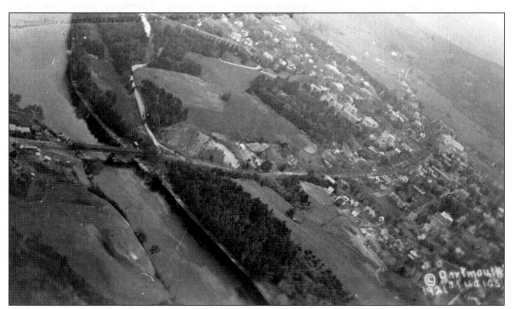

Perhaps taken the same day as the photograph above, this view looks east to the village and college area from over Norwich. To the left are Ledyard bridge and the village of Lewiston. (Author's collection.)

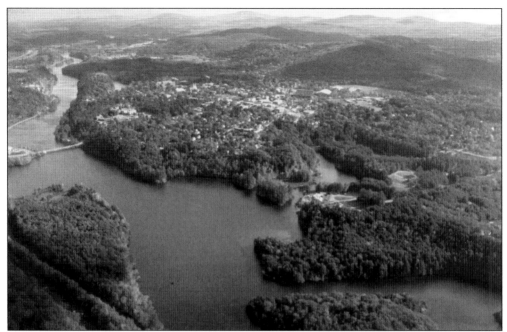

This 1993 aerial photograph looks down on the village and college area from about the Hanover-Lebanon town line. The completion of Wilder Dam in 1950 raised the Connecticut River water level about 20 feet, which is quite evident in this view when compared to earlier images. (Author's collection.)

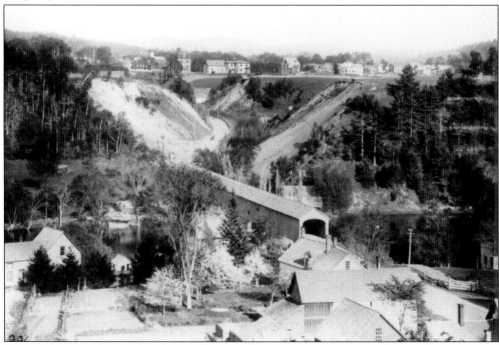

Here is the westerly portion of the village area as it appeared in 1892, showing Lewiston and the Ledyard bridge in the foreground. New houses along Prospect Street can be seen above the sandy, eroding embankments beside West Wheelock Street. (Author's collection.)

Two

THE EARLY COLLEGE

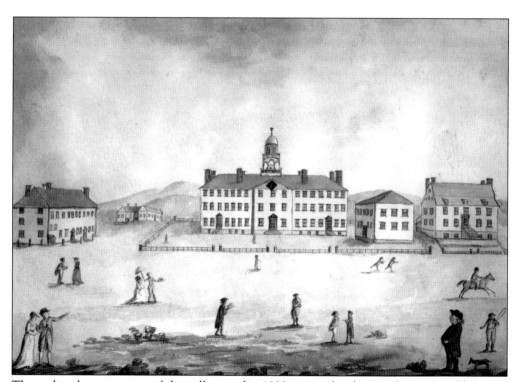

The earliest-known image of the college is this 1803 watercolor drawing by 11-year-old George Ticknor. In the center is Dartmouth Hall (1791). To the far left is Commons Hall (1791), and in the distance is John Wheelock's house (1786). To the far right is Eleazar Wheelock's house (1773), and adjacent to it and Dartmouth Hall is the college chapel, erected in 1790. (Dartmouth College Special Collections.)

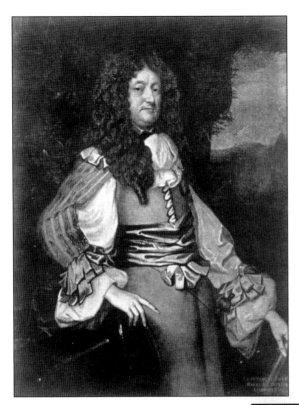

Eleazar Wheelock chose to name his new college Dartmouth after the prominent Englishman William Legge (1731–1801), the second Earl of Dartmouth. Legge served the British government as lord of trade and plantations, secretary of state for the colonies, and lord privy seal and lord steward of the household to King George III. In 1768, Legge secured a gift of 22 pounds to Wheelock and his new college from the king. (Dartmouth College Special Collections.)

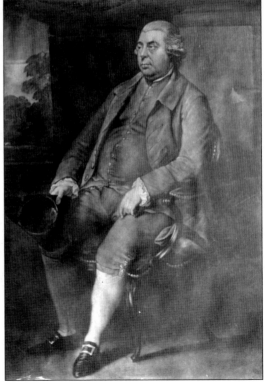

John Thornton was a London commoner of great wealth gained in trade, who also took a great interest in Wheelock's new college in North America. Thornton's generosity continued after the college moved to Hanover, although ceased five years later with the outbreak of revolution in the colonies. In 1829, the new Thornton Hall was named in his honor. (Dartmouth College Special Collections.)

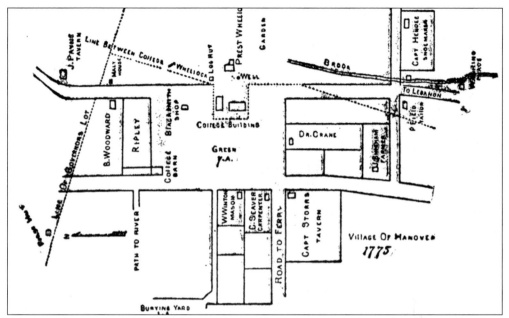

Jonathan Freeman, an early Hanover settler and land surveyor, laid out the college and village area for Wheelock in 1771, placing the 7.5–acre Dartmouth Green at the center set to the four points of the compass. The college occupied the east side, and house lots were established on the remaining three sides "for the accommodation of inhabitants . . . of the College." (Author's collection.)

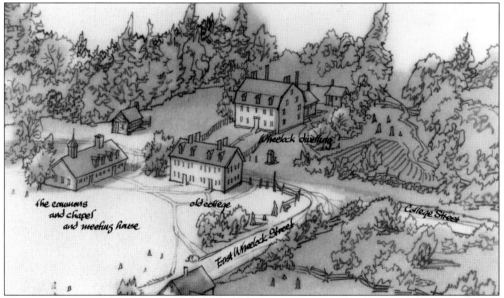

Here is part of a sketch rendered in 1964 that re-creates the four-year-old Dartmouth College campus as it probably existed in 1775, looking down on the southeast corner of the future green and the intersection of present-day Wheelock and College Streets. Wheelock's house is on the slight rise of land, now the site of Reed Hall. The two-story "Old College" building (1770–1771); the Commons Hall; and the first log hut (1770) are all visible. (Dartmouth College Special Collections.)

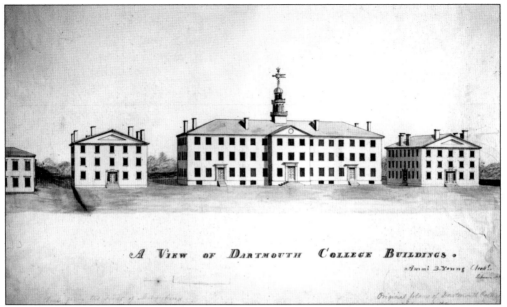

In 1828, the college commissioned Ammi B. Young (1798–1874), an architect originally from Lebanon, to design two new, three-story buildings to be used as dormitories for an estimated construction cost of $12,000. Both buildings were completed during the summer of 1829 and named Wentworth Hall and Thornton Hall in honor of two of the college's early benefactors. (Dartmouth College Special Collections.)

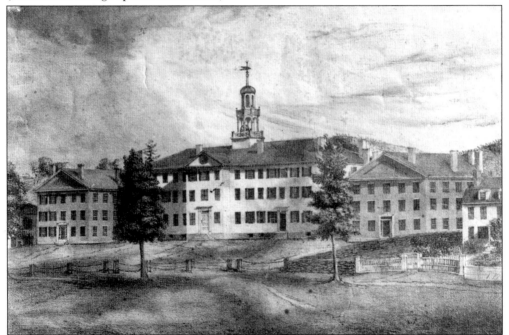

Prior to achieving fame as part of Currier and Ives, for about a year, lithographer Nathaniel Currier had a company named Stoddart and Currier, located at 137 Broadway in New York City. During that brief business arrangement in 1835, this very early lithograph was published of Dartmouth College. (Dartmouth College Special Collections.)

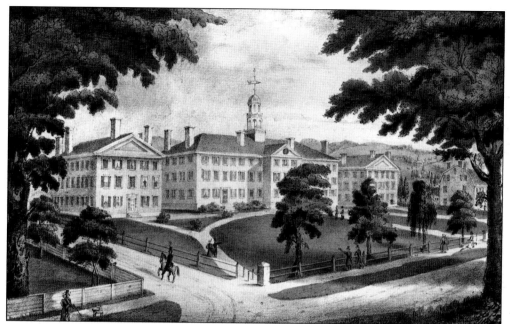

From about 1830 until it was removed in 1871, the area in front of Wentworth, Dartmouth, and Thornton Halls was enclosed with a fence and referred to as "the college yard." This lithograph shows the entire college facility in the 1830s, prior to the construction of Reed Hall. To the far right is the Eleazar Wheelock house on the future site of Reed Hall. (Dartmouth College Special Collections.)

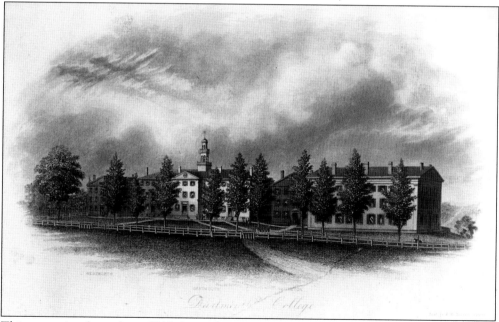

This engraving from about 1840 shows the entire college of four buildings. Wheelock's house was relocated to 4 West Wheelock Street in 1838, and Reed Hall was constructed in its place the following year—the result of a $19,500 gift from the estate of judge, congressman, and college trustee William Reed of Marblehead, Massachusetts. (Dartmouth College Special Collections.)

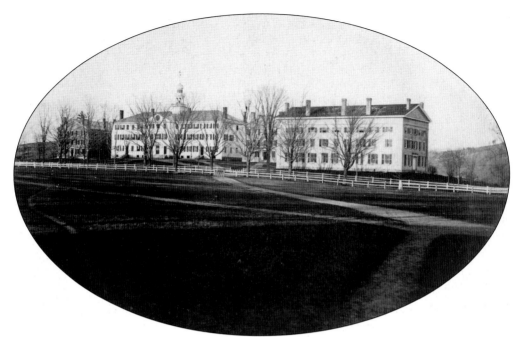

An early photograph, taken about 1860, shows the campus with the addition of Reed Hall. The building was designed by architect Ammi B. Young, who by that time had moved to Boston. He charged $277.75 for his plans. Construction was begun in 1839 by his brother Dyer H. Young, a contractor from Lebanon, and was finished for commencement in June 1840. A third brother, Prof. Ira Young, was the overseer of construction. (Dartmouth College Special Collections.)

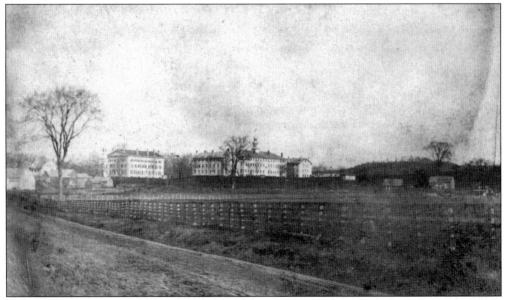

Here is another unusual view of the college from about 1860, looking from Lebanon Street. For many years until after the American Civil War and the construction of Bissell Hall in 1866, the entire Dartmouth College facility consisted of the four buildings on the east side of College Street and the observatory located up the hill in the college park. (Dartmouth College Special Collections.)

Comparatively little has changed in this view from about 1870, looking northeast across the green toward Dartmouth Row. The fence circling the green from 1836 until its removal in 1893 is clearly seen, and the state agricultural school's new Culver Hall can be seen in the far right. Notice that Rollins Chapel is yet to be built north of Wentworth Hall at this time. (Author's collection.)

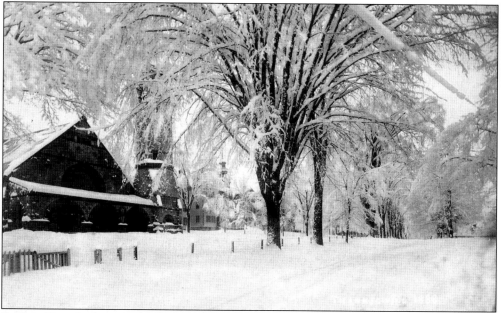

Rollins Chapel, photographed after an early, wet snow on Thanksgiving Day in 1888, was the result of a $30,000 gift from the family of Edward A. Rollins, class of 1851. John Lyman Faxon of Boston, Massachusetts, was the architect of the original building, which was enlarged twice, first in 1908 and again in 1912. The new building was dedicated on commencement day on June 24, 1885. (Author's collection.)

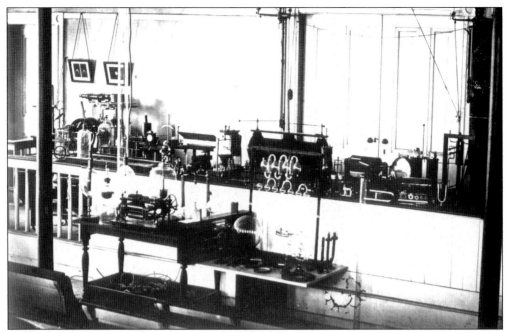

For many years, Reed Hall housed the college's library, physics, and philosophy departments, as well as student dormitory rooms. This photograph from about 1888 shows a physics laboratory in Reed Hall, which was the site of the first successful x-ray on record in the United States, taken in January 1896. (Author's collection.)

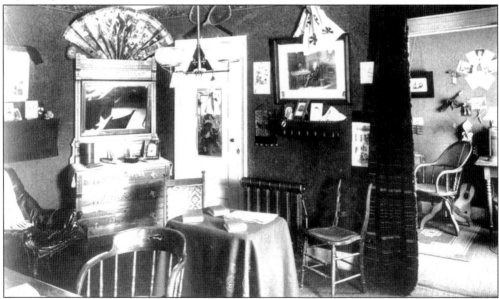

This view shows a typical dormitory room in Reed Hall about 1888. Because the college library was located in the building, there was a constant fear that fire could destroy its collections. In 1874, several years after the first gas-generating plant was constructed in Hanover, Reed Hall received new gas lighting. Likewise in 1875, steam heat was installed in the building six years after coal was first introduced to Hanover. These two steps greatly increased safety by eliminating open, burning stoves and kerosene-burning lamps that could be easily upset. (Author's collection.)

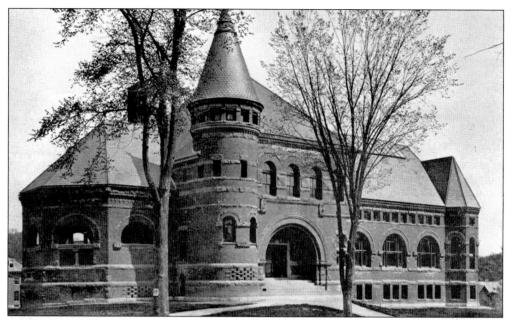

Wilson Hall, built as the result of a generous gift from George F. Wilson, a resident of western Massachusetts who never attended Dartmouth, was designed as the college's new 130,000-volume library by Boston architect Samuel J. T. Thayer. The new facility was dedicated on commencement day on June 24, 1885. A year earlier, the old Gates house that had occupied the site since 1785 was moved to 68 South Main Street. (Author's collection.)

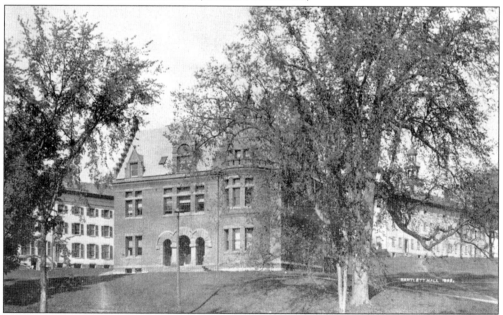

Another new Romanesque Revival–style building of the Victorian period constructed on campus by the college was Bartlett Hall, situated just east of Reed Hall. Built in 1890 as a facility for the Young Men's Christian Association (YMCA) and designed by architect Lambert Packard of St. Johnsbury, Vermont, the building was named for Samuel Colcord Bartlett (1817–1898), the eighth president of the college from 1877 to 1892. (Author's collection.)

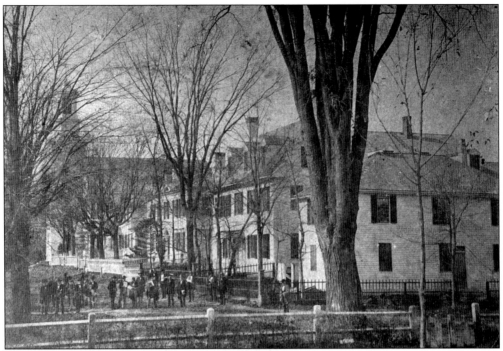

This very early view of Wentworth Street, taken looking west from in front of Wentworth Hall in 1854, is believed to be the oldest known photograph of Hanover. In the foreground, now the site of Webster Hall and Rauner Library, is Lang Hall (1799–1865), constructed as a general store with a second-floor hall; followed by Rood house (1824–1900); Lord house (1802); Choate house (1786); and the Church of Christ at Dartmouth College (1791–1931). (Author's collection.)

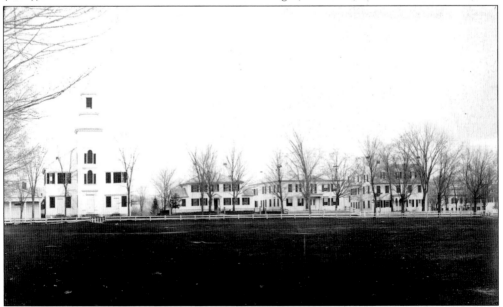

Here is a full view of the north side of the Dartmouth Green and Wentworth Street about 1867. By this time, Lang Hall had been removed. In 1869, two enclosed entrance vestibules were added to the front of the church. (Author's collection.)

Choate house, erected in 1786 by Eleazar Wheelock's son-in-law Rev. Sylvanus Ripley, is shown here at its original location on Wentworth Street. The house was first moved in 1927 when Baker Library was being constructed behind it and again in 1963 to its present location on North Main Street. (Author's collection.)

Lord house, erected in 1802 by William H. Woodard, who was a lawyer, treasurer of the early college, and grandson of Eleazar Wheelock, is shown at its original location. This house has been moved three times, the first was in 1920 in preparation of Baker Library's construction. Today the house is situated along Lyme Road opposite the golf course. (Author's collection.)

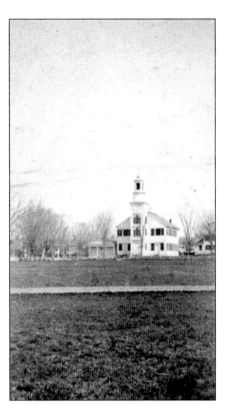

Here is a view from about 1867 of the First Church of Christ at Dartmouth College (1795) and the vestry building erected in 1841 on the site of the college barn (1772). Villagers often referred to the diminutive vestry and large church building beside it as the "calf and cow." Both buildings burned on the night of May 13, 1931. (Author's collection.)

Another view, taken about 1867, looks south on North Main Street from its intersection with Wentworth Street. In the distance, facing the south side of the green on the left is the Crane-Currier house (1771–1887) and the two buildings that made up the Dartmouth Hotel—today the site of the Hanover Inn. (Author's collection.)

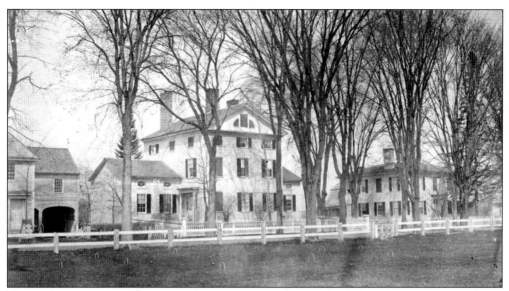

This is the west side of the green about 1865. Partially visible to the left is an early residence erected about 1774 by William Winton, a mason who died in the battle of Saratoga in September 1777. In the center of this view is the impressive residence constructed by Dr. Cyrus Perkins about 1815 that was for many years after the home of Prof. Edwin D. Sanborn. To the right is the home of Prof. Ebenezar Adams, erected in 1810. This property remained in his family until it was acquired by the college in 1902 as a site for Tuck Hall, later renamed McNutt Hall. (Author's collection.)

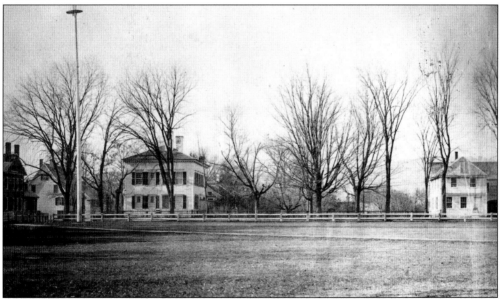

Originally from Salem, Massachusetts, Richard Lang was the first large-scale merchant within the village and constructed a general store with a hall above on the site of present-day Webster Hall. Very quickly accumulating wealth, in 1795 he erected this fine house at the northeast corner of West Wheelock and North Main Streets, where he lived until his death in 1840. This view shows the east side of the house that faced the green about 1865. To the right is the Winton house. (Dartmouth College Special Collections.)

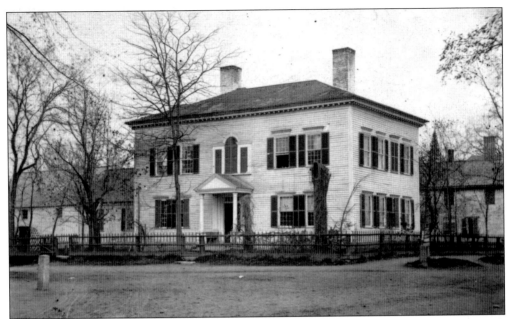

Here is another early view of the Lang house, looking from the front porch of the Dartmouth Hotel across the intersection of Main and Wheelock Streets. In 1875, the house was moved off the lot that is now the site of Dartmouth's College Hall and first relocated to 11 East Wheelock Street where it served as a fraternity house. In the 1920s, it was moved again to its present location at 23 South Park Street. (Dartmouth College Special Collections.)

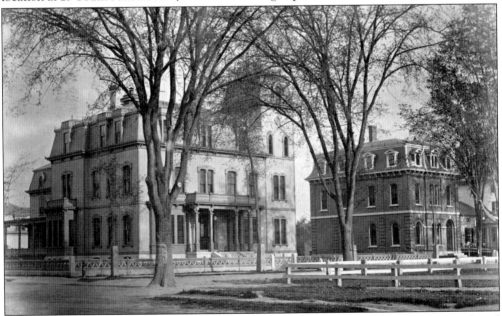

Adna P. Balch, a man who made a considerable fortune in early railroad investments, purchased Richard Lang's old house, had it removed from the site, and erected this contemporary second empire–style residence for himself in 1875. To the right is the Dartmouth Savings Bank building, constructed in 1870 as both a community bank and an office for the college treasure. (Dartmouth College Special Collections.)

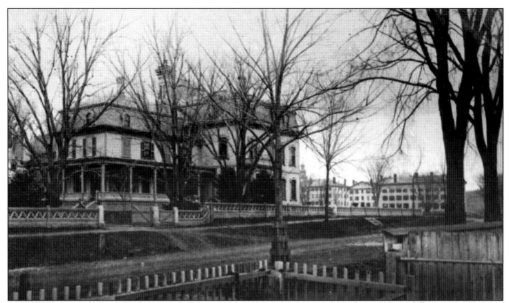

Balch's new home soon came to be known as the "golden corner," apparently a reference to both its opulence and its vibrant yellow exterior color scheme. By 1887, the property was purchased by Frank W. Davison, a local merchant. The first floor was converted to a dry goods store, and the second floor was rented to a college fraternity. This view looks from the present-day site of the Banwell building on West Wheelock Street about 1880. (Dartmouth College Special Collections.)

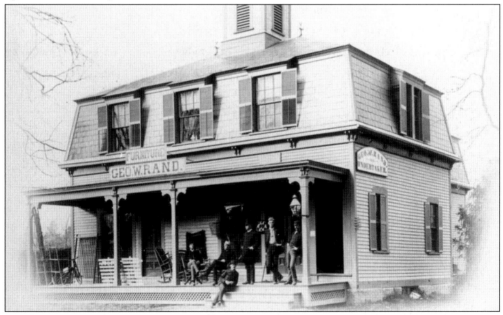

The stables behind Balch's mansion were as stylish as the main house. After Davison purchased the property in 1887 and converted the house for commercial use, he rented the stables to George W. Rand for a furniture store and undertaking facility. In 1900, the house partially burned, and the college acquired the entire premises. That year, Dartmouth constructed its College Hall building on the site. (Author's collection.)

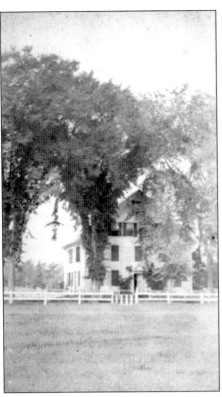

About 1784, Samuel McClure, the village tailor, barber, and postmaster, erected this large home for himself, which faced the green. It was partially on the site of present-day Parkhurst Hall for which it was torn down in 1910. This early photograph shows the house about 1867. (Author's collection.)

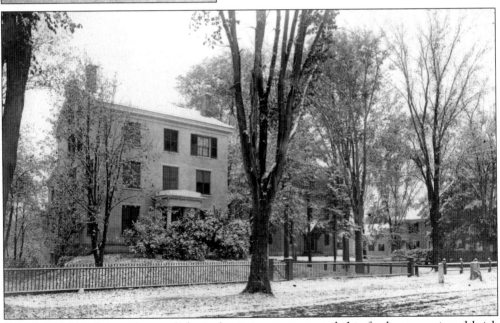

Oliver P. Hubbard, a professor of physical sciences, constructed this finely proportioned brick home in 1842, possibly designed by Ammi B. Young, on the North Main Street site partially occupied today by Parkhurst Hall. After the property was acquired by the college in the 1890s, the building briefly served as a dormitory until razed in 1910. (Dartmouth College Special Collections.)

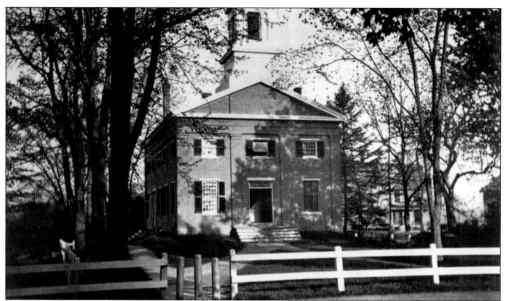

Chandler Hall, located between the college's present-day Parkhurst and Blunt buildings on North Main Street, was designed by Ammi B. Young and constructed in 1837. The facility was originally used by Moor's Indian Charity School, which was founded by Eleazar Wheelock in Lebanon, Connecticut, in 1754, prior to the founding of Dartmouth College. After disbanding Moor's school in 1849, the college substantially remodeled the building in 1871 and again in 1898 as space for the Chandler School of Science and Arts. (Author's collection.)

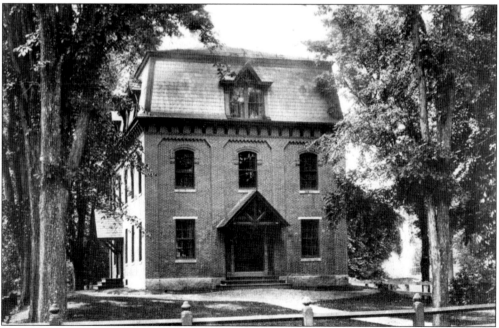

The remodeling of the old Moor's academy building in 1871 added a third floor of recitation and drawing rooms at a cost of $7,037.32; however, it came at a loss of the belfry and classic Greek Revival lines of Young's original design, which was, by the 1870s, very out of style. (Author's collection.)

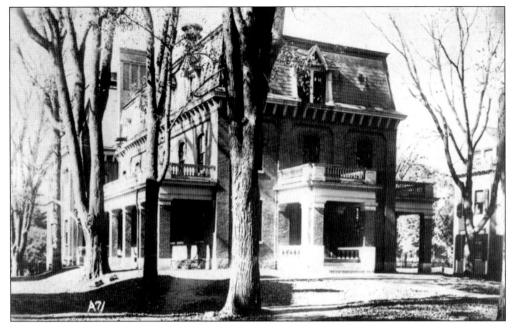

In 1898, Chandler Hall was once again not only remodeled, but also a large addition was built on to the rear of the facility through a gift of $28,000. By 1937, considered by many as "unquestionably the ugliest building in Hanover," the building was demolished long after the Chandler School had become a full part of Dartmouth College. (Author's collection.)

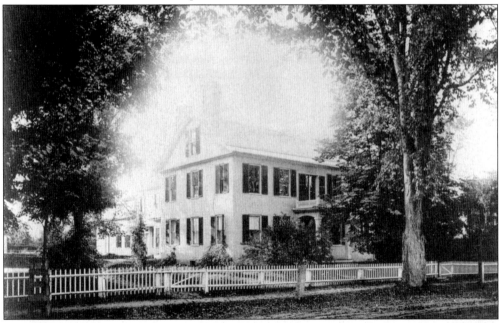

Rev. Zephaniah S. Moore, professor of languages, constructed his brick residence in 1810; however, for many years the house was owned by Dr. Dixi Crosby and is known as Crosby Hall today. Like many residential properties, the house was acquired by the college in the 1890s and was extensively altered in 1896. The building still stands on North Main Street. (Dartmouth College Special Collections.)

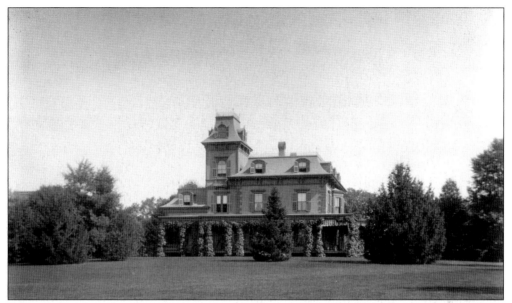

Professor and Dartmouth College trustee Rev. Henry Fairbanks of the famous St. Johnsbury, Vermont, scale-manufacturing family erected this impressive Second Empire home in 1864 on the present-day site of Russell Sage Dormitory. By the 1880s, the residence was owned by Hiram Hitchcock and his wife, Mary Maynard. In 1890, after Mary's untimely death, Hitchcock gave Hanover a new hospital in her name. The house was demolished in 1920 for the development of Tuck Drive. (Dartmouth College Special Collections.)

In 1780, Rev. Sylvanus Ripley and his wife, Abigail, daughter of Eleazar Wheelock, erected this small cape-style home on the present-day site of Silsby Hall. Daniel Webster roomed in the house during his senior year at the college in 1800, which is how it came to be known as Webster Cottage. First moved in 1828, today the building is situated farther north up North Main Street within sight of its original location. (Dartmouth College Special Collections.)

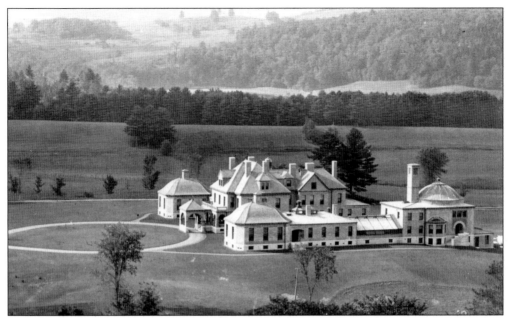

The Dartmouth Hospital Association was formed in 1885 with the purpose of constructing a hospital in Hanover. Seven acres of pastureland had been secured north of the college, but it was not until Hiram Hitchcock, a retired wealthy New York City hotelier, decided that he wanted to create a memorial to his beloved wife, Mary Maynard, that the new facility, shown here at its completion in 1893, became a reality. (Author's collection.)

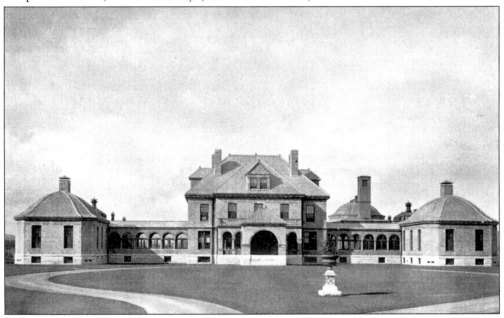

The new, 36-bed hospital was designed in the style of early Italian Renaissance architecture by Rand and Taylor Architects of Boston. Featuring the state-of-the-art pavilion layout concept—then the latest thinking in hospital design—the men's ward was to the left of the main building and the women's to the right. All but the old men's ward was demolished in the fall of 1995 after the hospital relocated to Lebanon. (Author's collection.)

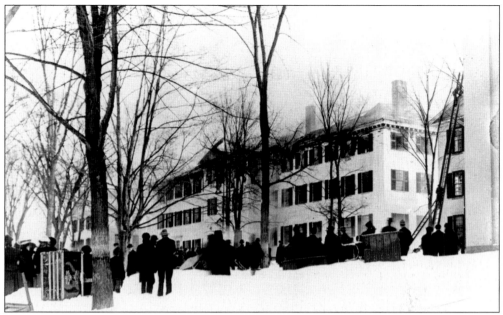

On the morning of February 18, 1904, with the temperature at 20 degrees below zero and students at chapel exercise, Dartmouth Hall caught fire from defective electrical wiring and completely burned with remarkable rapidity. Thick, dusty smoke prevented firefighters from effectively combating the blaze, and one student had to be rescued from a third floor window by ladder. (Author's collection.)

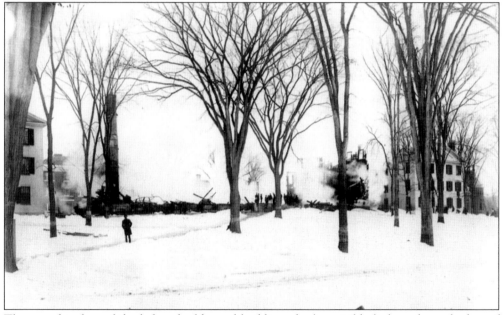

The complete loss of the beloved, old wood building, the last visible link to the early days of the college, became known to the Dartmouth alumni community—even as the building was burning. A trustee living in Boston, notified of the tragedy by telegram during the fire, quickly called a meeting saying this was "not an invitation but a summons." The building was rebuilt in brick that year. (Author's collection.)

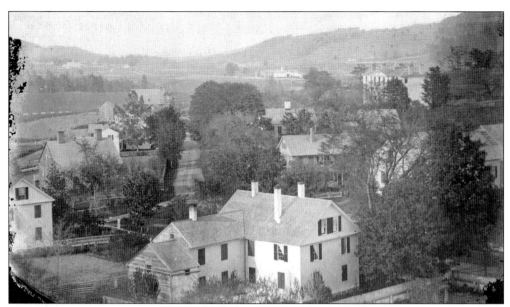

This early view, taken about 1865 from the tower of the Church of Christ at Dartmouth College on the green, looks northeast and down on the home of Abigail Dewey, now the site of the east wing of Baker Library. Looking north up College Street, the first medical school building, constructed in 1811, can be seen at the upper right. In the 1770s, this area was the village's first commercial area before the establishment of Main Street. (Dartmouth College Special Collections.)

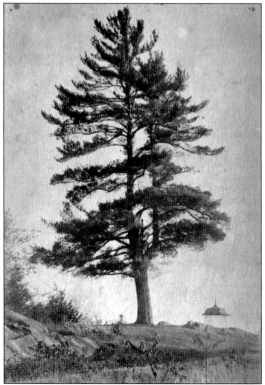

The "old pine," an early symbol of Dartmouth College, grew from the rocky ledge outcropping in the college park before finally being cut down in 1895. By then, it was damaged, diseased, and perhaps as much as 150 years old. Shown here about 1880 is the tree and an ornamental, iron summer house placed on the western summit of the college park that year. (Author's collection.)

This very early photograph shows the old pine with the Shattuck Observatory. Designed by Boston architect Ammi B. Young and constructed in 1852, the $4,800 astronomy facility was the gift of Dr. George C. Shattuck, class of 1803, who was also from Boston and a noted physician in his day. The metal-clad wood dome on top of this ingenious little building could be turned and opened up to better view the heavens. (Author's collection.)

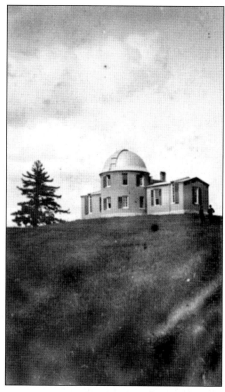

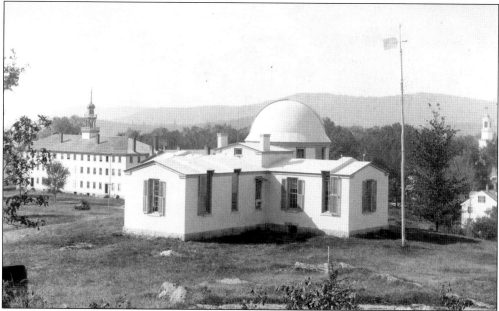

Looking southwest from the ledge outcropping in the college park, this view from about 1880 shows the back side of Shattuck Observatory and the original wood-frame Dartmouth Hall, finished in 1791. Note the absence of Rollins Chapel, which was constructed in 1884. In the distance to the far right is the steeple of the Church of Christ at Dartmouth College (1795–1931), located in front of the present-day Sanborn house at Baker Library. (Author's collection.)

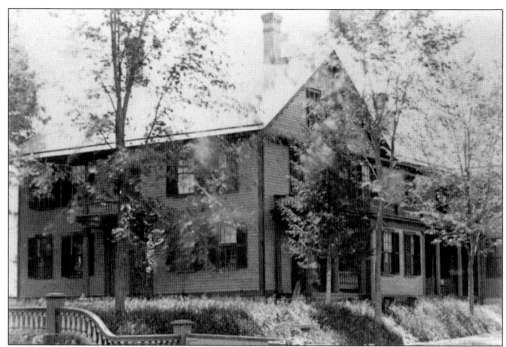

One of the first homes erected within the village area was at this site in 1771, now the location of the east wing of Baker Library. However, the home burned in the 1830s and was replaced by this home in 1842 by Abigail Dewey. The home was relocated to 24 East Wheelock Street in 1926 to provide space for Baker Library. (Author's collection.)

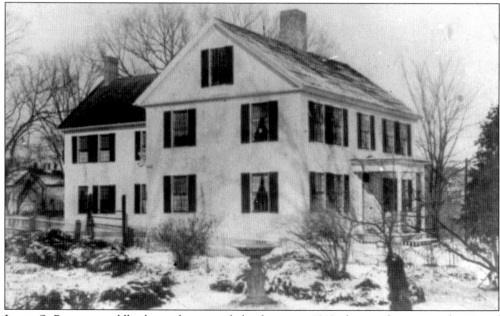

James S. Brown, a saddler by trade, erected this house in 1812 also on the present-day site of Baker Library's east wing at about the location of its east entrance. Made into a dormitory by the college in 1903 and called Elm House, it was also relocated to East Wheelock Street in 1926 and is today located beside the Dewey house shown above. (Author's collection.)

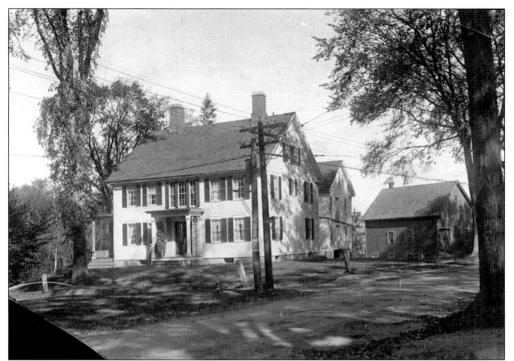

Deacon Benoni Dewey, a blacksmith who moved to Hanover in 1779 from Springfield, Massachusetts, erected this house at 38 College Street in 1809 from money won in a $500 lottery. By 1916, the Sigma Alpha Epsilon fraternity acquired the property and, in the 1920s, demolished the old building and constructed its present brick facility. (Author's collection.)

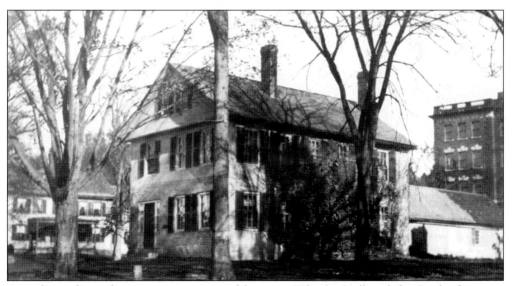

Once located on what is now open ground between Wheeler Hall and the Steele chemistry building at College Street was this brick-and-stone residence constructed by Luke Dewey in 1832. The home burned on the night of January 1, 1918. Beyond it is the 1810 residence of Aaron Hutchinson that is now situated on Lyme Road. (Author's collection.)

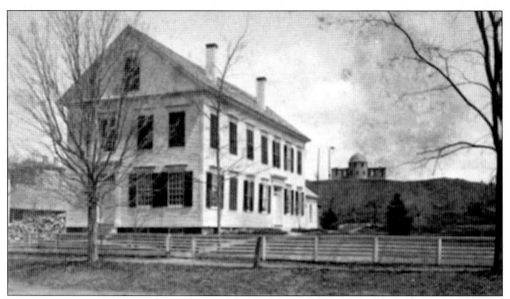

Like many early buildings around the campus area, this building erected by Samuel H. G. Rowley has served numerous uses at several locations. Originally situated behind the present site of Rollins Chapel, it was moved about 1835 to the present site of Wheeler Hall on College Street, as shown in this 1865 view. Its uses ranged from store to recitation hall to dormitory to residence, and it was moved again in 1904 to Elm Street and became an apartment house. Note Shattuck Observatory in the background. (Author's collection.)

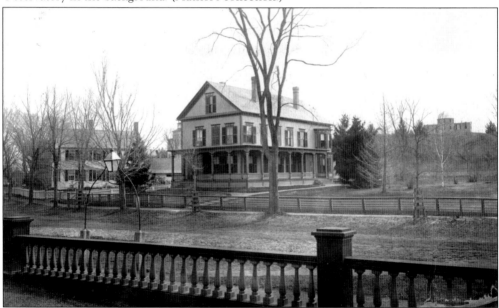

By the mid-19th century, the invention of mechanized woodworking equipment for shaping decorative, ornamental trim in factories and the advent of railroads to ship those manufactured materials made adding ornate porches and other architectural embellishments to older homes economically possible. An example is seen here about 1880 in Prof. Ira Young's house. The Luke Dewey house is to the left, and Shattuck Observatory is to the far right. In the distance is the medical school. (Dartmouth College Special Collections.)

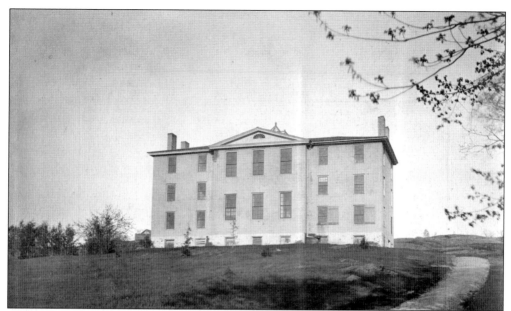

The Dartmouth Medical School, established in 1797, is the fourth-oldest such institution in the country. In 1809, the New Hampshire state legislature appropriated $3,450 for the construction of this 75-by-32-foot, three-story brick building. Located on the west side of the college park above College Street, the facility was completed in 1811 at a cost of $1,217.14 more than the appropriation. (Dartmouth College Special Collections.)

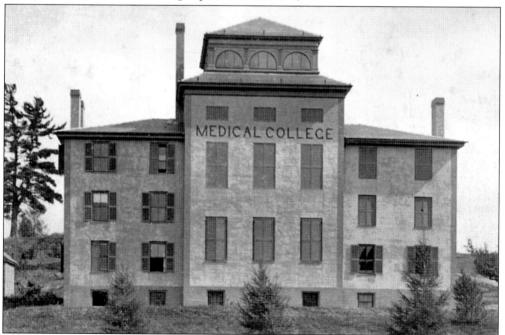

A gift from E. W. Stoughton, a lawyer in New York City, allowed for extensive alterations to the building in 1871. Most notably was the raising of the center roof area, constructing a lantern to light the building's interior; and establishing a museum of pathological anatomy. The building was razed in 1963. (Author's collection.)

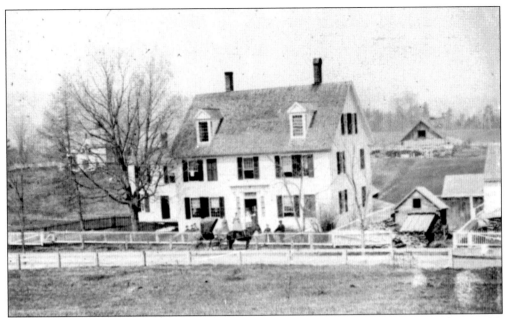

This house, still standing at 42 College Street, was erected by William A. Dewey about 1820. By mid-century, the property housed Hanover's first hospital, which was established by Dr. Dixi Crosby, and it was located there until his retirement in 1870. At that time, the building was returned to use as a residence. This view, taken from the medical school building, shows the property as a hospital about 1865. (Author's collection.)

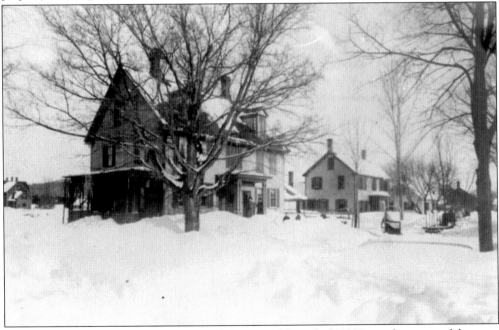

In March 1888, the Northeast experienced the "great blizzard of 1888"—perhaps one of the most infamous snow events in American history. This photograph looks north on College Street in the storm's aftermath. In the foreground is the house that is still standing at 42 College Street and the home immediately beyond. (Author's collection.)

Hanover's recorded history has little or no mention of the construction and early ownership of this picturesque cape-style residence that once stood on the southwest corner of College and Maynard Streets. The house was intentionally burned in order to remove it in the mid-1960s and make way for the hospital's new mental health facility. Today that building is part of the college's Sudikoff math and science complex. (Dartmouth College Special Collections.)

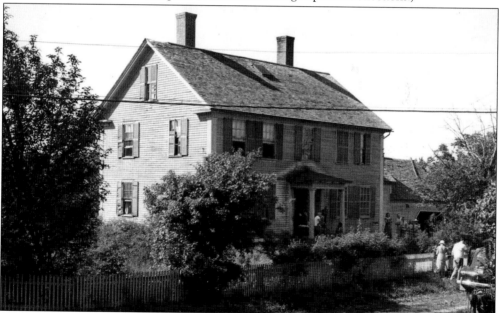

Friends and relatives are arriving to celebrate Mary Jane Dewey's 103rd birthday in this photograph taken on August 14, 1940. The house, located at 56 College Street on the present-day site of the Dana Biomedical building, was erected by her father, George Dewey, in 1842 when she was five years old. The house was torn down in 1962 to allow for the expansion of the Dartmouth Medical School. (Dartmouth College Special Collections.)

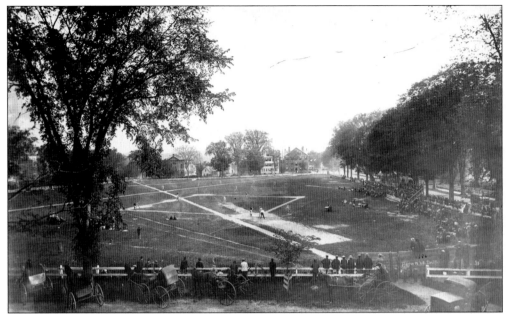

A Dartmouth versus Brown University baseball game is being played in this view of the green taken looking south from the Church of Christ at Dartmouth College. The 7.5-acre green was first laid out in 1771; however, it was not until 1831 that it was drained, leveled, graded, seeded, and a bisecting road was relocated to the perimeter. From 1836 until it was removed in 1893, a granite post and wood rail fence encircled the green's edge. (Author's collection.)

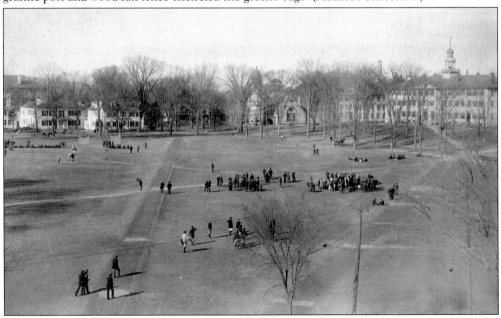

This view, looking northeast across the Dartmouth College green, was said to represent a last look at the comparatively small, regional old college that gave way to a much larger and changed internationally known institution in the 20th century. That change was first noticed through many of the buildings located around the green, including the fiery destruction and subsequent rebuilding of Dartmouth Hall in 1904. (Author's collection.)

This is how the south side of the green looked about 1867. Bissell Hall (1867–1959), located to the left on the present-day site of Hopkins Center, was completed that year. The two large buildings to the right were the Dartmouth Hotel and the Crane-Currier house (1773–1887), which were both destroyed in the great fire of 1887. (Dartmouth College Special Collections.)

From the intersection of Main and Wheelock Streets, this 1875 view looks east toward the Gates house (1785–2007), which is now the site of Wilson Hall. To the right is the brick Dartmouth Hotel building and its wood-frame annex. Partially visible beyond that is Bissell Hall, the college's gymnasium facility. (Dartmouth College Special Collections.)

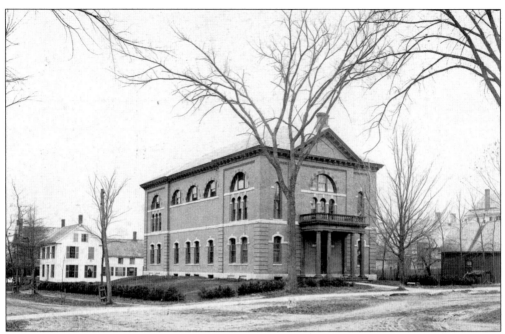

Bissell Hall, constructed in 1867 on the present site of Hopkins Center, was the first building of any significance built by the college since Reed Hall in 1839 and Shattuck Observatory in 1852. Planned as the college's first athletic facility, it housed bowling lanes on the first floor and an open gymnasium on the second floor. Designed by Boston architects Richards and Parks, the building was the gift of George A. Bissell, class of 1845. (Author's collection.)

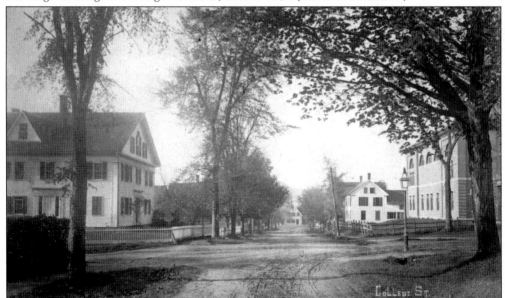

Prior to the construction of the Hopkins Center beginning in 1959, College Street extended south to intersect with Lebanon Street. Showing one of the village's earliest streets, this view looks south about 1875, with East Wheelock Street crossing in the foreground, the Gates house on the left, and Bissell Hall on the right. Lebanon Street is shown in the distance. (Dartmouth College Special Collections.)

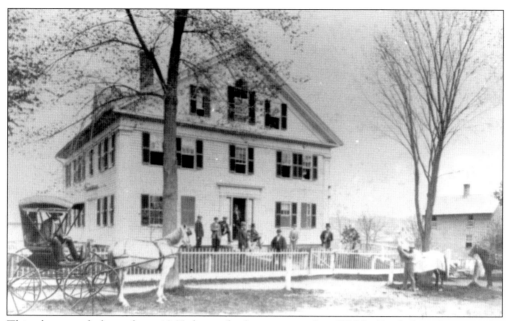

This photograph from about 1865 shows the house erected in 1785 by Dr. Laban Gates on the present-day site of Wilson Hall. First constructed as a two-story home with a hipped roof, the residence was enlarged and its roofline was changed, probably early in the 19th century. Gates lived in the house until his death in 1836. In 1884, the house was moved to 68 South Main Street and subsequently demolished in 2007. (Author's collection.)

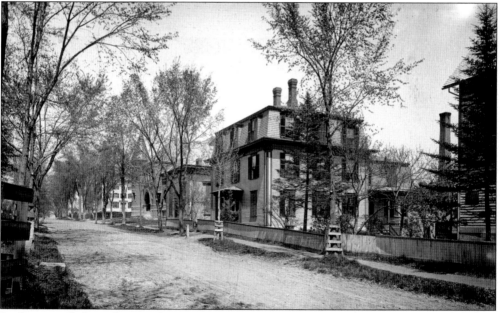

Looking north from about midway up College Street between Wheelock and Lebanon Streets, this 1890 view shows Wilson Hall, the new college library completed in 1885, and Reed Hall beyond. In the foreground is the residence of Sarah E. Sweet, erected in 1874. The small building next to it is the fraternity hall of Kappa Kappa Kappa, erected in 1860, which today is the site of the Hood Museum. (Dartmouth College Special Collections.)

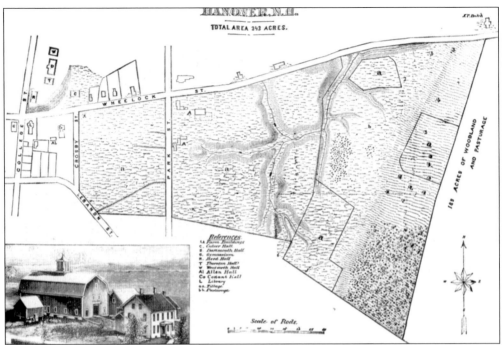

In 1868, the state opened the New Hampshire College of Agriculture and Mechanical Arts in Hanover as an adjunct of Dartmouth College. Established in 1866 as a result of the Morrill Land Grant Act of 1862, the new school quickly acquired a total of 343 acres of land in and adjacent to the campus and village area. As noted on this map from about 1885, that land is now part of Dartmouth's present-day athletic facilities and the Valley Road–area neighborhood. (Author's collection.)

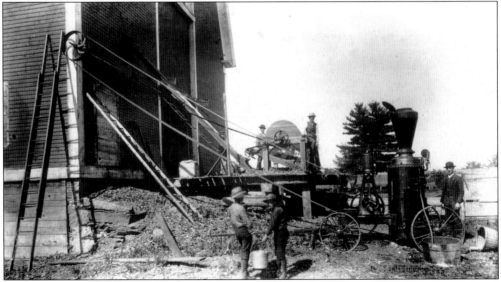

As the name implied, an integral part of the state's educational program at the agricultural school was farming. In this 1890 photograph, students of the state school, often disparagingly referred to as "dungies," are shown cutting ensilage at the school's barn located at the corner of Park and Wheelock Streets. (Author's collection.)

This photograph, taken from the upper window of Culver Hall looking southeast, shows the state school's barn erected in 1875 at Park Street and pasture and tillage land beyond at the base of Velvet Rocks. The land in the foreground was also part of the state school and is now the site of Dartmouth's numerous athletic facilities. The farm complex continued to expand until the school relocated to Durham in 1893. (Author's collection.)

Here is an interesting photograph taken in 1875 looking south from the college park across the state school's land between Park and Crosby Streets. In the right foreground is the Richard Lang's old house that was moved from its original location at the corner of North Main and Wheelock Streets (see page 34). In the distance are Lebanon Street, Sand Hill, and Velvet Rocks. (Author's collection.)

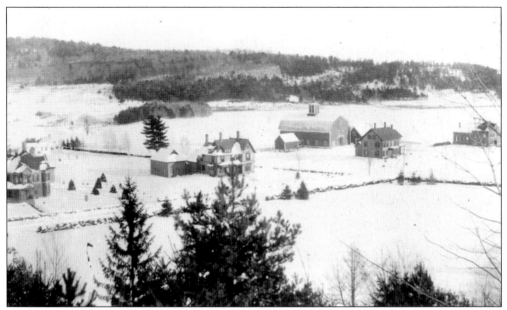

After establishing the agricultural school at Hanover in 1868, the state commenced development of a farm complex at the southeast corner of Wheelock and Park Streets in 1875. By the early 1890s, when this wintry photograph was taken, the operation included a house for the farm superintendent erected in 1882 and a state-of-the-art experimental station constructed in 1889 that was funded by the Hatch Act of 1887. (Author's collection.)

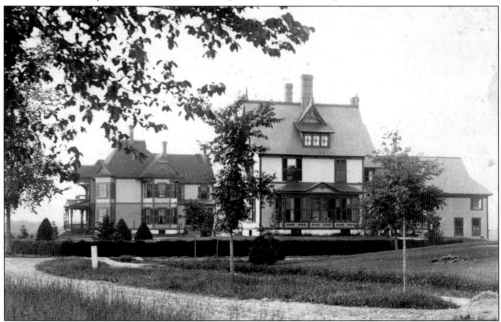

Charles H. Pettee, a professor at the state agricultural school in 1884, erected the house and stables shown in the foreground. That same year Hanover dry goods merchant Frank W. Davison added the impressive Queen Anne–style residence just beyond the Pettee house. Both of these Victorian buildings still stand at the intersection of Park and Wheelock Streets. (Author's collection.)

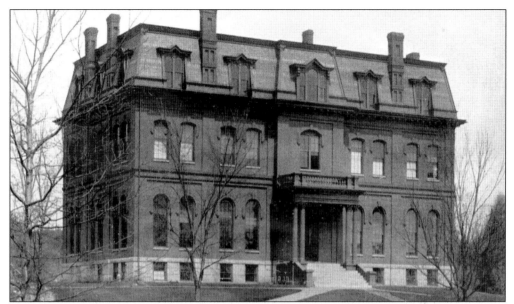

Culver Hall was undoubtedly the most impressive and substantial building constructed at Dartmouth College by the State of New Hampshire as part of the state school. It was a classroom and laboratory building located on East Wheelock Street a short distance from Reed Hall. Designed by architect Edward Dow of Concord, the 100-by-60-foot masonry structure was later purchased by Dartmouth in 1893. Named for Gen. David Culver of Lyme, an early benefactor of the agricultural school, the building was razed in 1929. (Author's collection.)

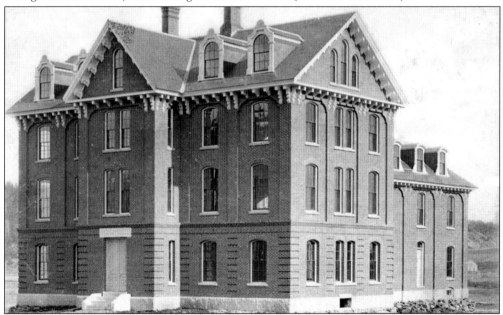

The dormitory and dining hall for the 50 or so students of the state school was Conant Hall, which was also designed by Dow and constructed in 1874 at a cost of $22,358. After the state moved the school from Hanover to Durham, Dartmouth acquired the Italianate-style building, renovated it, and renamed it Hallgarten Hall. In 1920, after construction of Topliff Dormitory, the front portion of the building was demolished. (Author's collection.)

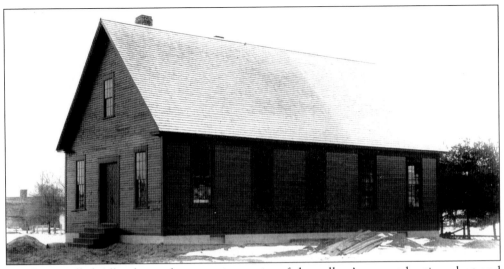

On the so-called Allen lot at the approximate site of the college's present heating plant and behind Conant Hall, the state erected this simple wood-frame building called Allen Hall, named for its location. Used as an experimental machine shop, the building was removed after the college acquired the property and constructed the heating plant in 1898. Note the early gambrel roof house in the distance on Lebanon Street. For more information, see page 89. (Author's collection.)

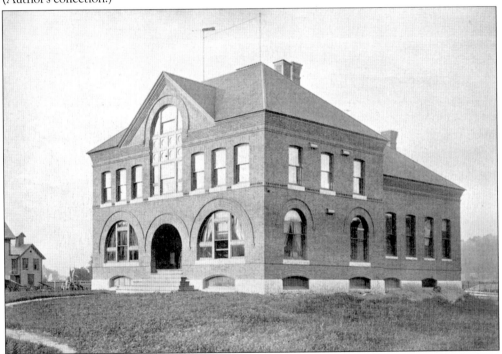

The last building that the state constructed in Hanover before deciding to relocate to Durham in 1893 was the Experimental Station, finished in 1889. Still standing at South Park Street, the facility was briefly utilized by the state school for agricultural experiments before being acquired by Dartmouth College and subsequently becoming the home of the Thayer School of Engineering. (Author's collection.)

Three

MAIN STREET

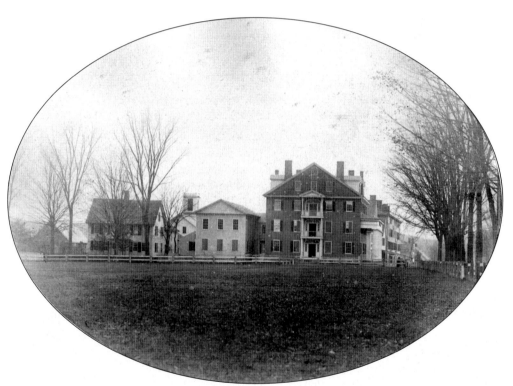

From 1780, when Capt. Ebenezer Brewster of Preston, Connecticut, converted his newly erected house into a tavern, the Hanover Inn corner at the intersection of Main and Wheelock Streets has continuously remained the site of lodging and vitals in the village. This view from about 1860 of the south side of the green shows the second building to occupy that site—the brick Dartmouth Hotel and its wood annex. To the east is the house erected in 1773 by Hanover's first physician, Dr. John Crane. Partially visible in the rear is the large livery stable facility for the hotel. (Dartmouth College Special Collections.)

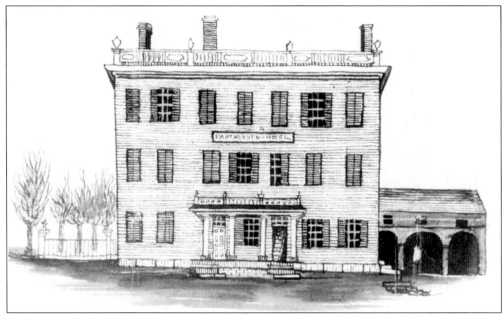

During 1813, Col. Amos Brewster had his elderly father and tavern keeper falsely called out of town so that he could remove the family's tavern building and construct this new brick hotel facility in its place, today the site of the Hanover Inn. This sketch by John Willard, dated March 25, 1826, shows the Main Street face of the brick building as originally constructed and the hotel's stables in the right rear. (Author's collection.)

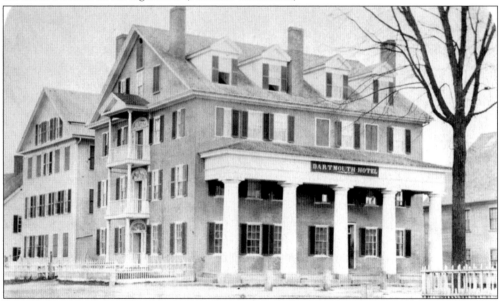

The Dartmouth Hotel remained relatively unchanged until the 1840s when Elam Markham added a small wood annex building on the east side, and a pitched roof replaced the original flat balustrade roof on the main brick building. By about 1865 when this photograph was taken, inn keeper Horace "Hod" Frary had enlarged the annex with a spacious upstairs hall and added forth-floor dormer windows, tiered porches facing the green, and a substantial Greek Revival–style colonnade facing Main Street. (Author's collection.)

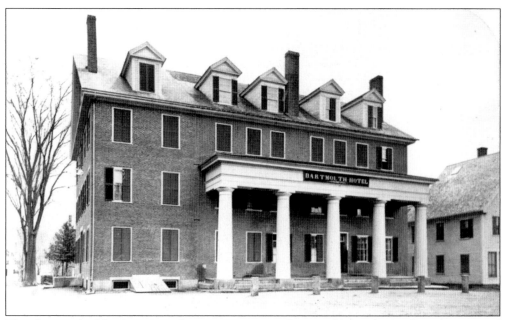

The always colorful, often cantankerous, enterprising Frary and his wife, Amelia, who acquired the hotel in 1857, made an estimated $40,000 worth of alterations and improvements to the money-making facility over the course of 20 years. This included extending the northerly end of the brick building in October 1867, as illustrated above; however, it was at the expense of the multitiered porches and small garden area facing the college green. (Author's collection.)

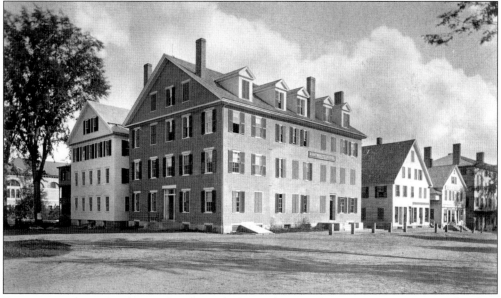

Frary was a man of soft speech, silvery locks, and a saintly appearance. However, his fiery temper and violent language were often fiercely aroused by reading the newspapers of the day or by "those damned students" when they noisily danced clogs under the hotel's colonnade and madly yelled his nickname "Hod–Hod–Hod," then ran away. Therefore, in 1875, much to the architectural detriment of the building, the colonnade was ordered removed, as noted in this 1876 view. (Dartmouth College Special Collections.)

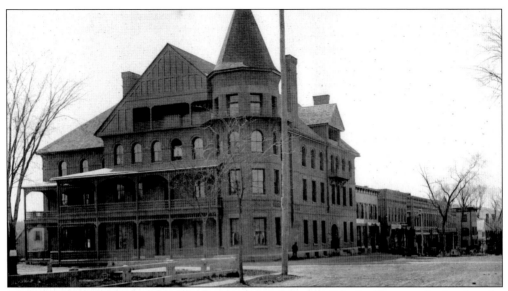

During the night of January 4, 1887, the Dartmouth Hotel and the buildings on both sides of it completely burned. Because Horace and Amelia Frary choose not to rebuild, in 1888, the college purchased the vacant lot for $5,000. That March, the trustees voted to construct a new hotel on the site. The replacement building was designed by architect Lambert Packard of St. Johnsbury, Vermont, and was completed for occupancy in time for Dartmouth's commencement in 1889. Here is the new hotel around 1890, named the Wheelock after the college's founder. (Dartmouth College Special Collections.)

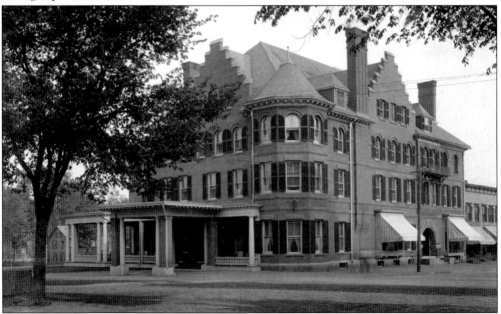

From the start of construction, the hotel rebuilding project was plagued with problems. The townspeople stole building materials during the night, and the project ran significantly over budget. After completion, the building proved to be unsound and poorly designed, and by 1902, the college undertook more then $58,000 of alterations to the 100-guest facility and renamed it the Hanover Inn. (Dartmouth Collect Special Collections.)

In spite of a large addition constructed in 1924 to the east side of the Hanover Inn, which provided much-needed dining room and kitchen space and four floors of additional guest rooms above, by 1966, it was time to replace the aging 1889 problem-plagued building. Therefore, shortly after commencement day in June, demolition of the old Victorian structure began. (Dartmouth College Special Collections.)

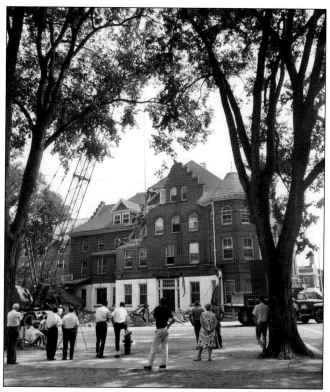

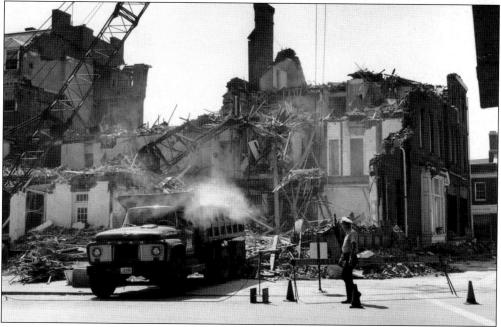

For several weeks or more during the summer of 1966, the old inn was reduced to rubble and trucked away, soon to be replaced by a larger, more modern hotel facility. The demolition work provided this author, then a 13-year-old boy growing up in Hanover, a summer's worth of entertainment. (Dartmouth College Special Collections.)

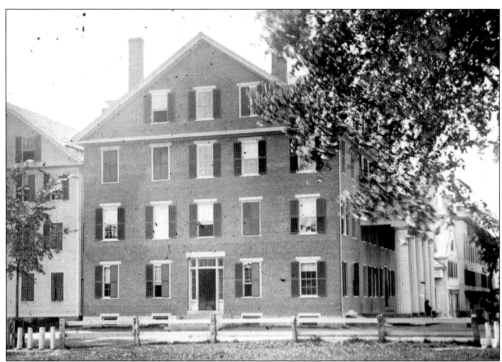

The classical serenity of the Dartmouth Hotel (1813–1887) is shown here about 1870. (Author's collection.)

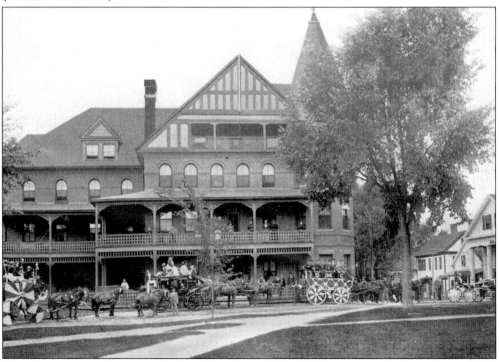

The Victorian exuberance of the Wheelock (1889–1966) is pictured here about 1890. (Author's collection.)

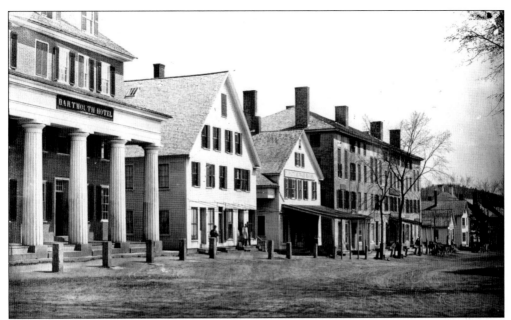

This is the east side of South Main Street about 1865. Beside the Dartmouth Hotel is a building first erected as a tavern several miles outside the village on Greensboro Road and moved to this site by Jonathan G. Currier in 1839. Likewise, the smaller wood building beyond was made up of an old stable and moved onto the site that is today the location of the Lang building. Beyond that is the Tontine block, constructed in 1815. (Dartmouth College Special Collections.)

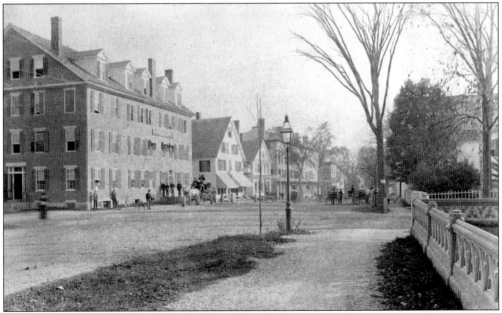

A similar view to that above, taken from in front of the present-day College Hall about 1880, shows the east side of South Main Street. All of the first four buildings, starting with the Dartmouth Hotel at left, completely burned during the night of January 4, 1887. Note the gas lamps introduced to the village in 1872 after a gas company was first chartered. (Dartmouth College Special Collections.)

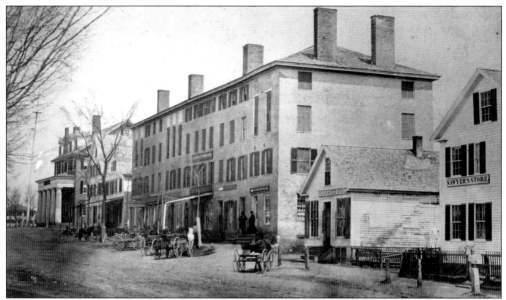

From the time of its construction in 1815 until its destruction by fire in 1887, the 40-by-140-foot brick Tontine block was the village's principal commercial structure. Designed and constructed by H. L. Davenport, an enterprising carpenter from Connecticut who initially came to Hanover to build the first medical school facility in 1811 (see page 47), the building proved a financial disaster. The small shop building in the foreground of this 1860 photograph is today the Ledyard National Bank building. (Dartmouth College Special Collections.)

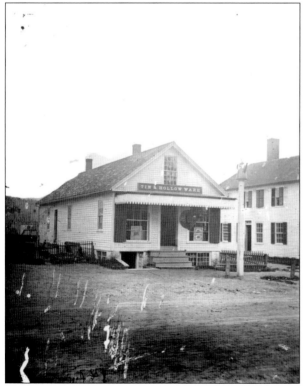

There appears to be no record of when and by whom this small shop building was first erected at 38 South Main Street, which today is part of the Ledyard National Bank building. It is known to have been a grocery and liquor store in 1842, and about 1865 when this image was probably made, it had become Albert Wainwright's tin shop. (Dartmouth College Special Collections.)

During the winter of 1869, Wainwright enlarged his small, single-story tin shop by widening the old building on the north side and adding two full stories above. Village photographer H. O. Bly, with a studio next door in the Tontine block, took this construction view and many other early photographs of the village and campus area used in this book. (Author's collection.)

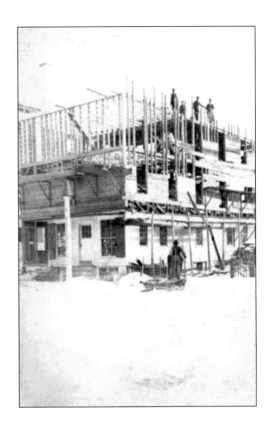

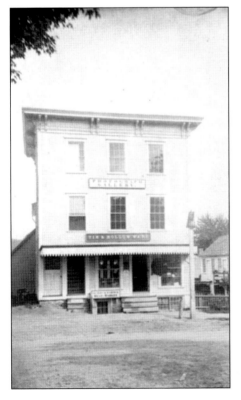

Bly was apparently so impressed by Wainwright's expanded building that not only did he take this photograph upon the project's completion in 1869, but he also relocated his studio to an upper floor. In 1990, the building was once again extensively renovated to become the offices of Ledyard National Bank. (Author's collection.)

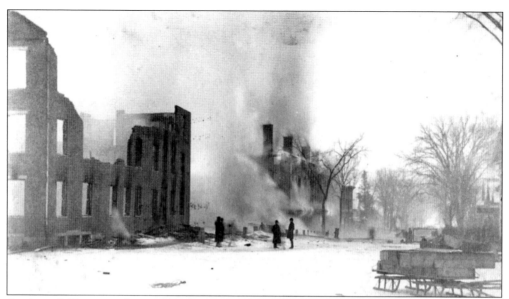

At about 2:00 a.m. under a still and moonless sky on January 4, 1887, with temperatures in the village at a bitter 20 degrees or more bellow zero, a fire started in a defective chimney within the wooden annex building of the Dartmouth Hotel. Soon the blaze was completely out of control, first consuming Dorrance Currier's home (the old Crane house seen on page 59) and then spreading to the brick hotel structure. By the time this early morning image was taken, the Tontine block was engulfed in flames. (Author's collection.)

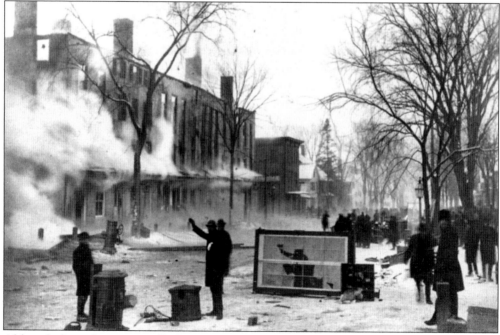

Although the night air was still, the two wooden buildings immediately south of the hotel were soon ablaze because of their close proximity to each other. It was hoped that the 12-foot-wide alley on the north side of the Tontine building and its brick walls might allow the block to escape catching fire; however, that was not to be. (Author's collection.)

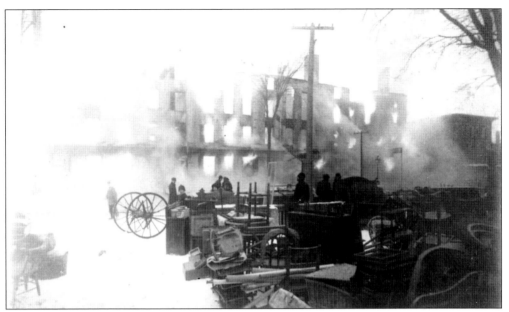

By daybreak, the entire Tontine block was ablaze, and all of the buildings to the north of it were reduced to smoldering ruins. Dartmouth students, usually a ready source of firefighting manpower, were still away on Christmas break. At times, according to eye-witness accounts, it appeared as if all of Main Street might become consumed by the advancing flames. (Author's collection.)

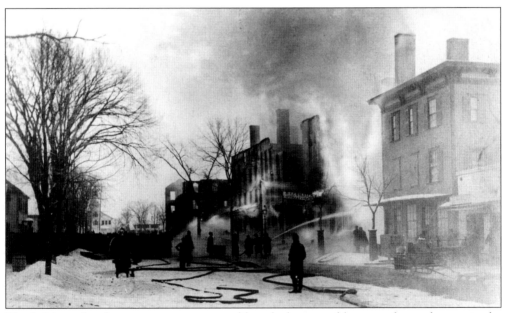

The Lebanon fire department was contacted by telephone, and between five and seven in the morning, a steam-driven pump engine arrived by railroad flatcar at the Lewiston station. It was drawn uphill to the burning village by teams of horses—perhaps the true heroes of the night. Using the steam pump to apply a steady stream of water upon the south wall of the ruined Tontine block, the fire was finally halted. By 9:00 a.m. it was no longer threatening Albert Wainwright's wooden tin shop building. (Author's collection.)

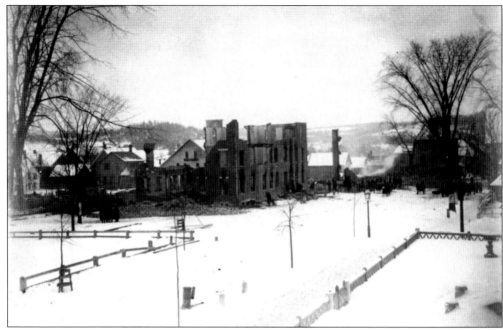

By later in the day on January 4, 1887, the central corner and very heart of the village was a smoking ruin, as seen in this view looking south from the roof of the old Dartmouth Savings Bank building. To the immediate left is the green; and to the right is the ornate fence of A. P. Balch's house—the "golden corner" (see page 34). (Author's collection.)

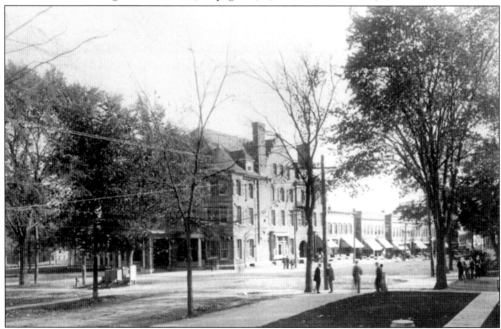

Main Street quickly rebuilt, as seen in this 1905 view looking from the front steps of Dartmouth's new College Hall building that was built on the site of the golden corner. Across the intersection is the recently refurbished Hanover Inn that was constructed in 1889 to replace the destroyed Dartmouth Hotel. (Author's collection.)

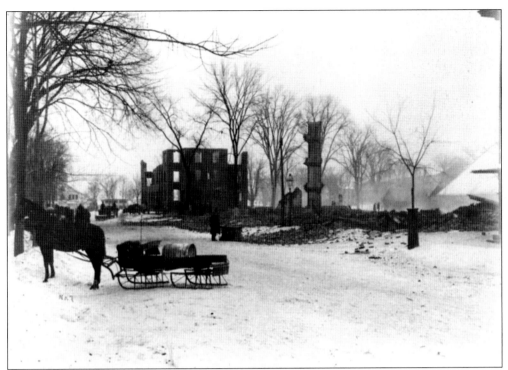

The smoldering ruins of the former Tontine block lay beside Albert Wainwright's tin shop building in this view looking north up South Main Street by H. O. Bly. Bly's photographic studio was located in Wainwright's building and barely escaped destruction the night before. (Author's collection.)

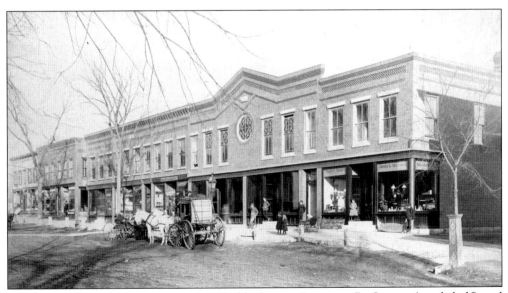

The two owners of the destroyed Tontine block were Dorrance B. Currier (north half) and John L. Bridgman (south half). They rebuilt the property during the summer of 1887. Although the new structure was the same length as the old building, it was of greater depth but only two stories tall. (Dartmouth College Special Collections.)

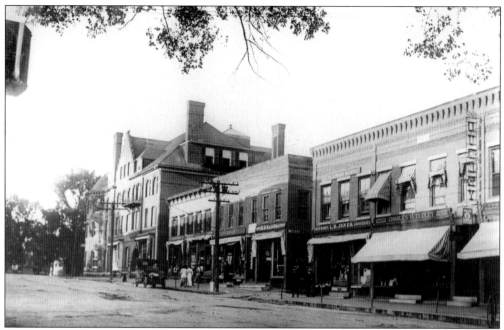

On the site of the two wood-frame buildings totally destroyed in the great fire, both commercial structures were rebuilt in 1887. Elijah Carter erected the northerly wooden building, and his brother H. L. Carter constructed the southerly building in brick masonry. They are shown in this photograph from about 1910. (Dartmouth College Special Collections.)

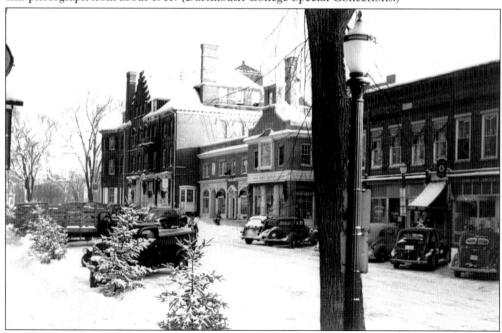

In 1936, the two 1887 buildings constructed by the Carter brothers burned, although no adjacent structures were destroyed. In 1937, Dartmouth College, which owned the property by then, constructed the new Jens Fredrik Larson–designed Lang building. It is seen here in this wintry view by photographer David L. Pierce, taken at Christmas in 1941. (Author's collection.)

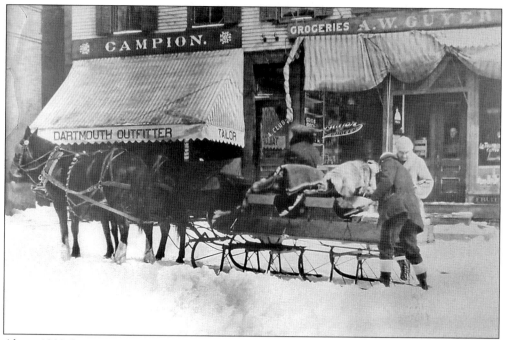

About 1882, James W. Campion left Ireland for the United States, where he first apprenticed as a tailor and haberdasher in the Springfield and Amherst, Massachusetts, area. In 1907, with his new wife, Anna, and a six-month-old son, James Jr., he settled in Hanover and opened a store in the Guyer building beside the Hanover Inn. (Campion family.)

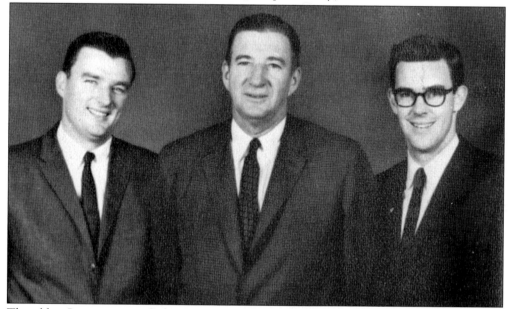

The elder Campion retired in 1929, although he continued to work for his son until 1937. James Jr. (center) steadily expanded the business, by now a Main Street institution; and was in turn joined by his sons, James III (left) in 1950 and E. Ronan (right) in 1961, seen here in a 1962 store catalog illustration. James Jr. died in 1968, and James III died in 1982 at age 53. The store closed in 1993. (Dartmouth College Special Collections.)

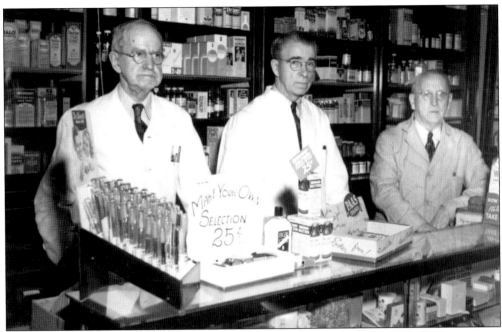

In 1918, Bob Putnam (left) purchased the Rexall drugstore started by Lucien B. Downing in 1868. Until its closing in the early 1980s, the store was a Hanover institution, especially for the soda fountain and homemade ice cream. This 1950s photograph shows Putnam with several longtime store employees. (Author's collection.)

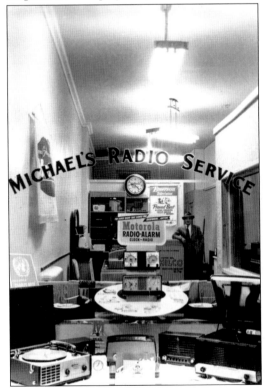

Before finally settling at its present 4 Allen Street location in 1963, Michael's Radio Service had numerous locations, including the one seen here at 32 South Main Street about 1952. Begun in 1942 by Michael Pizzuti, who was originally from New York City, the business is today carried on by his son Frank; however, it is now called Michael's Audio-Video. (Author's collection.)

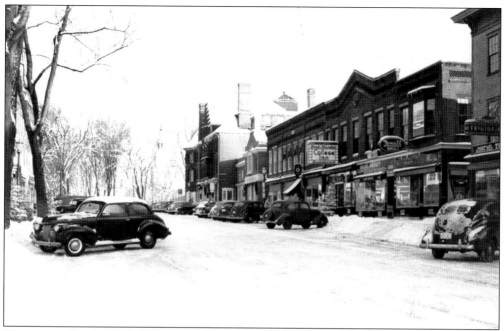

This view, taken by professional photographer David L. Pierce, looks north from in front of the municipal building and shows the east side of South Main Street at Christmastime in 1941. The old Hanover Inn (1889–1966) is at the "inn corner," and a corner of the Hanover Hardware Store is visible in the foreground. (Author's collection.)

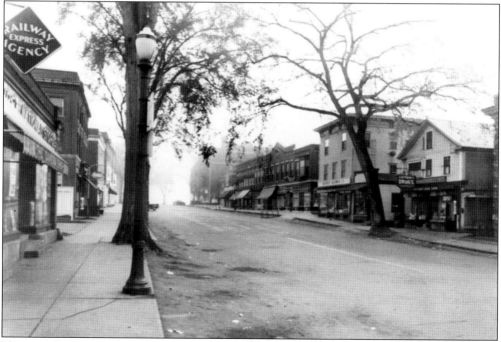

Photographer Ralph W. Brown took this image looking north up South Main Street from opposite the Lebanon Street intersection at 6:00 a.m. on May 15, 1949. To the immediate left is the Bishop block, today the location of Molly's Restaurant. (Author's collection.)

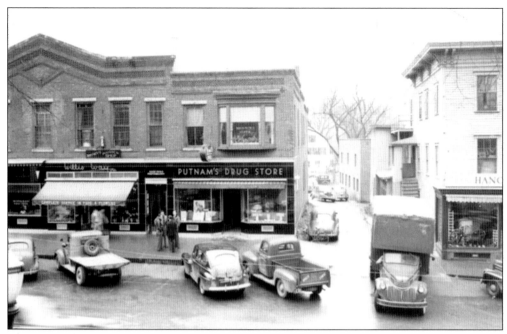

This view of Main Street from about 1950 was taken from the second-floor courtroom of the municipal building and looks down the alleyway between Bob Putnam's drugstore and the Hanover Hardware Store. On the second floor above Putnam's is David Pierce's photography studio. (Author's collection.)

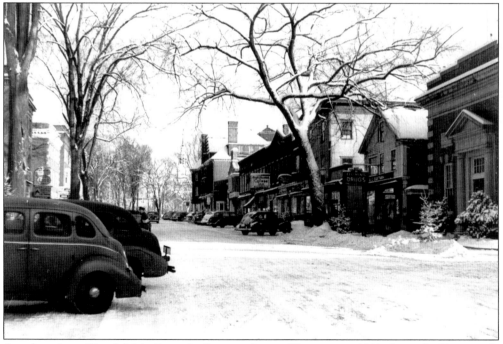

Another view of South Main Street by Pierce, taken at Christmas in 1941, shows the Dartmouth Savings Bank, Eastman's drugstore, and the Hanover Hardware Store buildings on the east side of the street. (Author's collection.)

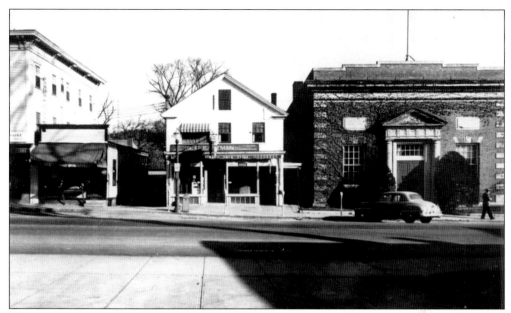

This view was photographed on a quiet Sunday morning in 1956 prior to the demolition of Eastman's drugstore building in 1959 to make way for expansion of the Dartmouth Savings Bank, shown at right. To the left is the Tanzi Brothers grocery store. (Author's collection.)

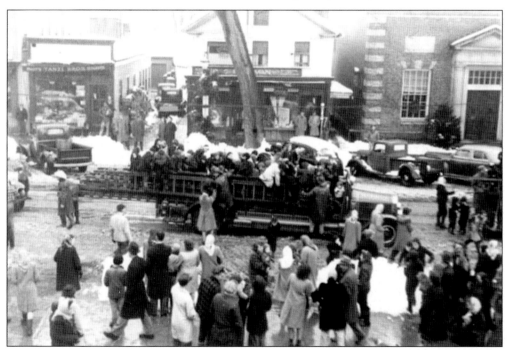

For many years, an annual winter holiday event for Hanover's children was a ride on a fire truck from the school on Lebanon Street, through the campus area, and to the fire station on Main Street, where Santa Claus listened to their wishes and dispensed candy. This photograph shows a group of children arriving at the fire station about 1948. Tanzi Brothers, Eastman's drugstore, and the Dartmouth Savings Bank are across the street. (Author's collection.)

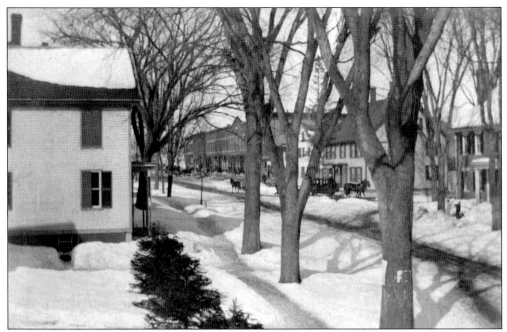

Looking from the present-day site of the Nugget Theater toward the Lebanon Street intersection about 1900, Capt. Ebenezer Brewster's original 1780 house on the site of the Hanover Inn is visible. Used as a tavern, it was moved to this location in 1813 to make way for the new Dartmouth Hotel (see page 60). (Dartmouth College Special Collections.)

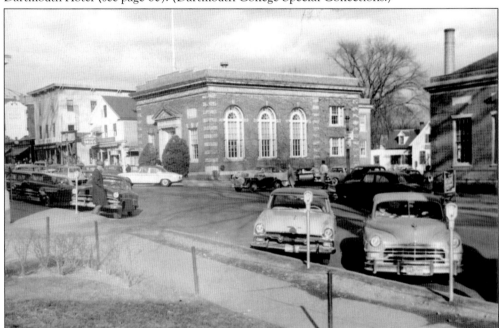

After removal of the old wood-frame house shown in the photograph above, the second building constructed in the village for the Dartmouth Savings Bank was competed on the site in 1913. This view, taken from about the same vantage point, shows the Lebanon Street corner in 1956. (Author's collection.)

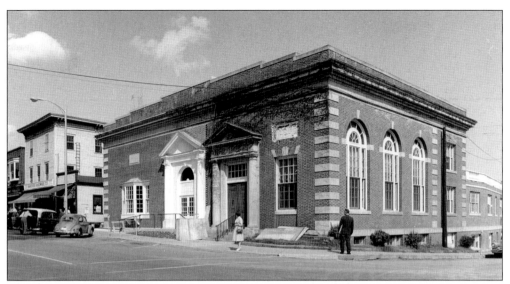

Although owned by the Dartmouth Savings Bank, the facility also housed the Dartmouth National Bank, a completely separate institution. In 1959, construction began to double the building size, and for a brief time during construction in 1960, the building actually had two front doors—the old and the new. (Dartmouth College Special Collections.)

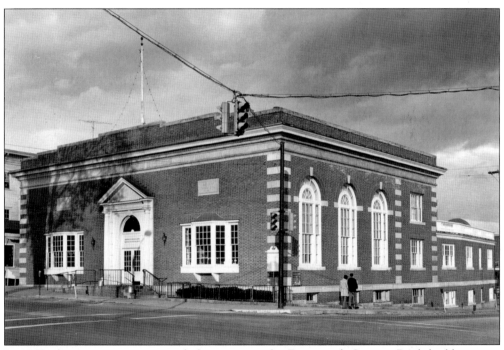

In 1960, the major expansion and alterations to the Dartmouth Savings Bank building were completed; and this is how the building looked for the next 17 years. In 1976, the Dartmouth National Bank, a tenant in the building, moved into its own new facility at 63 South Main Street. The following year, the Dartmouth Savings Bank once again extensively remodeled its building to look as it still appears today. (Author's collection.)

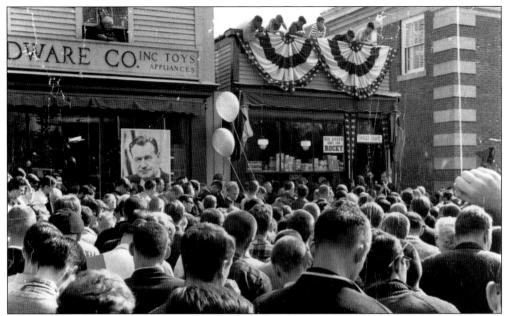

Angelo Tanzi, a stonecutter by trade, emigrated from Italy, and by 1897, he had established a fruit and grocery store on the east side of Main Street. After his retirement in 1927, three of his six sons continued the business. This view of the front of the store was taken on October 19, 1963, as students and townsfolk awaited the arrival of presidential candidate and New York governor Nelson A. Rockefeller. (Dartmouth College Special Collections.)

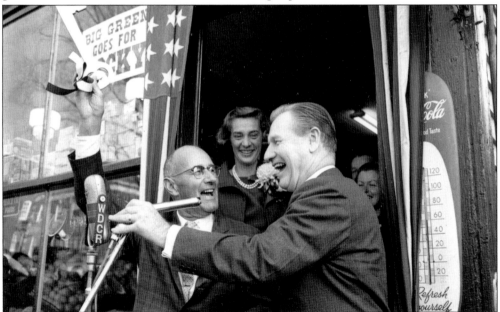

Until closing on June 30, 1969, Tanzi's was a Main Street institution and the center of village life. Regardless of the event, its origins were usually traceable back to Tanzi Brothers grocery store. Here is presidential candidate and New York governor Nelson A. Rockefeller (Dartmouth class of 1930), with his wife, Happy, receiving the ceremonial key to the city from Harry Tanzi (left), Hanover's honorary mayor, on October 19, 1963. (Dartmouth College Special Collections.)

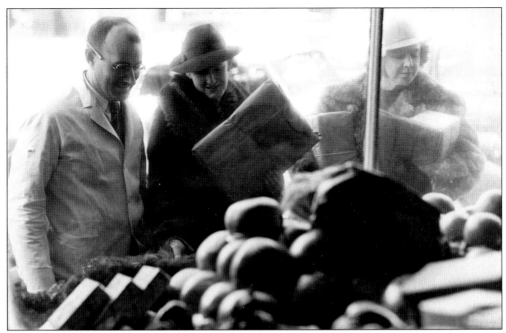

This 1940s photograph, looking through the front window of Tanzi's store from inside, shows Harry assisting several smartly dressed Hanover women with their selection of fresh fruit. In addition to the high-quality fruit and produce, the Tanzi brothers were also known for their lively and, at times, fresh bantering and conversation. (Dartmouth College Special Collections.)

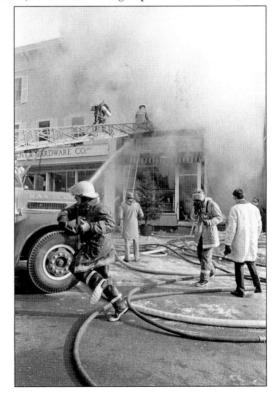

After the Tanzi brother's closed their store on June 30, 1969, the little 14-by-42-foot-long building became home to Arthur Gault's Specialty Shop. Several days after Christmas in December 1975, the building, thought to be about 90 years old, caught fire as a result of defective wiring and was destroyed. Today the lot remains vacant. (Author's collection.)

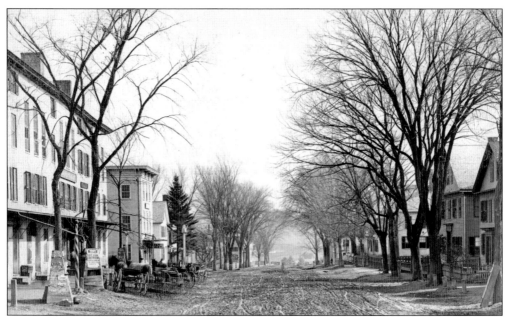

Taken on South Main Street from the area opposite Allen Street, this 1870 view looks south down the muddy thoroughfare toward West Lebanon. The house at the immediate right is today the site of the Musgrove building. The south end of the Tontine block is at left followed by Albert Wainwright's tin shop, which is home of the Ledyard National Bank today. (Dartmouth College Special Collections.)

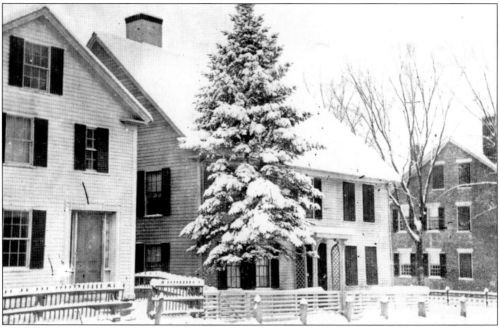

A wintry view from about 1870 shows the house (left) originally constructed about 1820 by Jabez A. Douglass, which was Eastman's drugstore from 1938 until it was razed in 1959 (see page 77). Beside it on the corner of Lebanon Street is the building originally constructed in 1780 as a tavern on the site of the Hanover Inn and moved to this location in 1813. (Author's collection.)

This photograph from about 1860 of the Lebanon Street intersection shows a corner of the house illustrated on the opposite page that was once located on the site of the present bank building, and it also shows the impressively large brick house constructed in 1835 by Maj. William Tenney, a village blacksmith. In 1929, it was razed to allow construction of a new post office building. (Author's collection.)

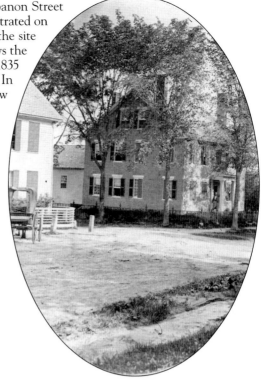

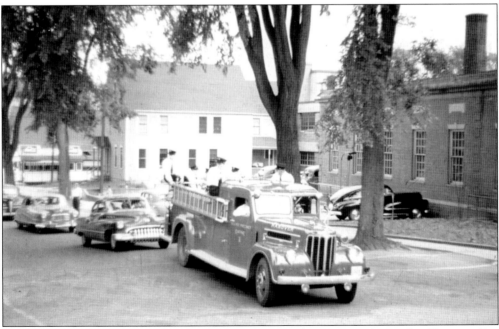

The occasion for this 1954 photograph is unknown; however, it shows the Hanover Fire Department's 1948 Maxim Engine No. 1 at the Lebanon Street intersection. Beyond the post office building is the east side of Lebanon Street, including a once-popular diner located at what is today the entrance into Dartmouth College's 7 Lebanon Street building. (Author's collection.)

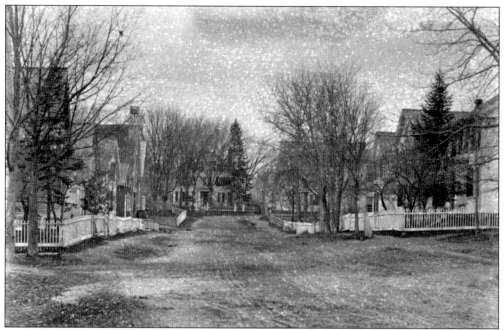

Taken about 1860, the quality of this photograph is grainy, but it shows the 19th-century character of Lebanon Street looking toward the Main Street intersection. The large gabled house is on the site of the present Nugget Arcade building. Most of the buildings shown on the left burned in 1883. (Dartmouth College Special Collections.)

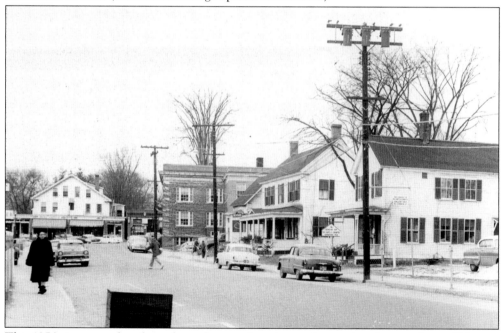

This 1956 view was taken from about the same location as the previous image, almost 100 years later. The same house on Main Street is still standing; and the back side of the Dartmouth Savings Bank building is very apparent. The three buildings to the right were razed in 1959 as part of the college's Hopkins Center redevelopment. (Author's collection.)

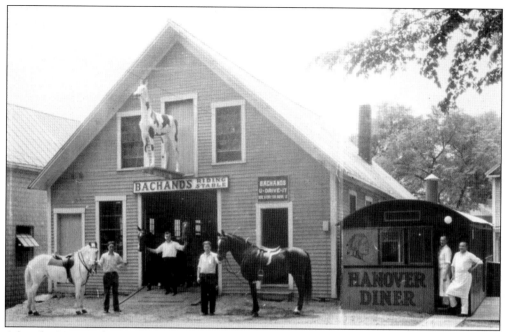

After the "great Lebanon Street fire of 1883" ravaged much of the south side of Lebanon Street, the area was quickly rebuilt with a variety of simple commercial structures, like this livery stable facility on the site of today's 7 Lebanon Street building. It is believed that the diner was added in the early 1920s around the time this image was made. (Author's collection.)

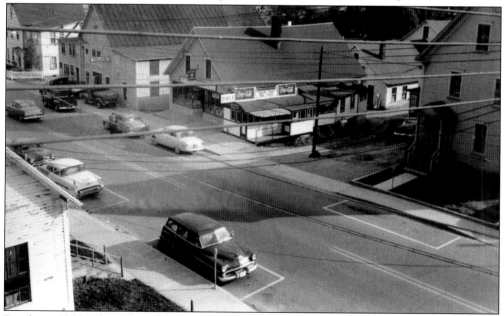

By about 1956, when this photograph was taken looking from the roof of the Dartmouth Savings Bank building down onto Lebanon Street, the diner still remained; however, the Hanover Hardware Company had a paint store in the former livery stable building. Since 1921, Trumbull-Nelson Construction Company was headquartered in the large building beyond. Today it is the site of the 7 Lebanon Street building. (Author's collection.)

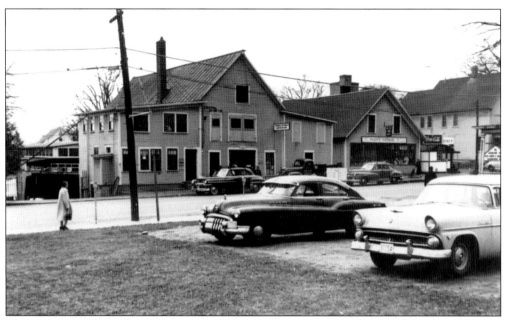

This 1956 view looks from approximately the future entrance to the Hopkins Center across to the south side of Lebanon Street. Seen are the Trumbull-Nelson Construction Company's main office and carpentry shop (formerly Masterson's blacksmith shop), the Hanover Hardware Company's paint store, and the diner. The building to the far right was razed in 1966. Today it is the site of the Hanover Park building. (Author's collection.)

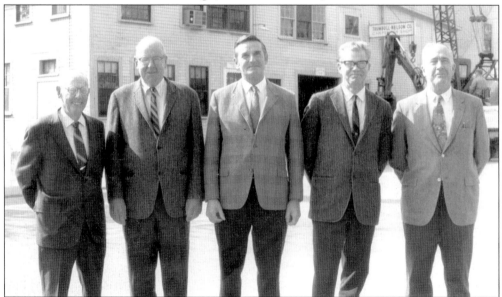

The Trumbull-Nelson Construction Company moved out of the village area to its new location in 1972 and prepared to raze its old buildings. The man who founded the company in 1917, Walter H. Trumbull (left), stands beside Dale H. Nelson, who was his longtime associate from 1925 until they became partners in 1947. Also shown in this historic photograph are the then current owners of the company, from left to right, Donald P. Smith, Clinton B. Fuller, and Leonard M. Ufford. (Trumbull-Nelson.)

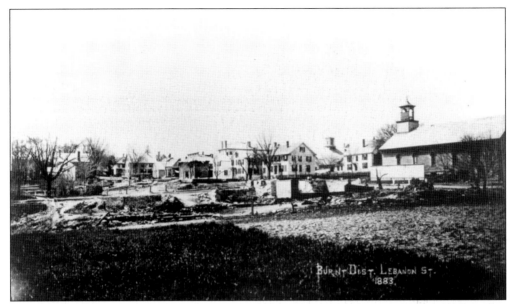

Long called the "great Lebanon Street fire of 1883," the blaze started on May 5, a windy Saturday, the result of children playing with matches in a barn located at Sargent Place. Strong winds from the southeast quickly spread the flames, and the entire village might have been lost without the help of a firefighting company and steam pump engine from Lebanon. Thirteen buildings were destroyed, as seen in this view looking northwest toward Main Street. (Author's collection.)

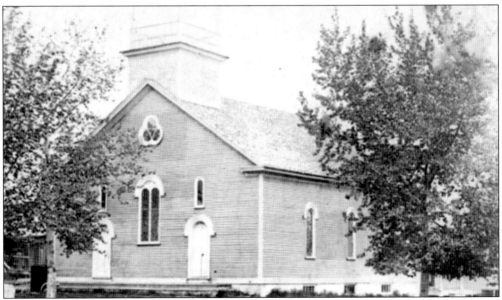

In the spring of 1841, a band of Hanover Methodists erected a new church on the north side of Lebanon Street, as shown in this 1870 photograph and also in the image above. Their efforts were short-lived, and in 1851, the building passed into the hands of the Episcopalians. (Author's collection.)

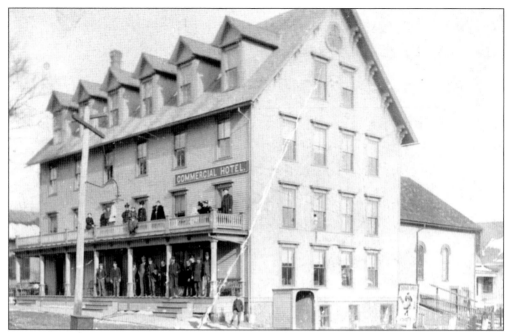

By 1876, the Episcopal Church moved into its new facility on West Wheelock Street, and the old building on Lebanon Street was sold to the Kibling family, who converted it into an opera house. In 1887, the Kiblings added the front three-story hotel building, seen here about 1890. The original church structure is visible behind the new addition. (Author's collection.)

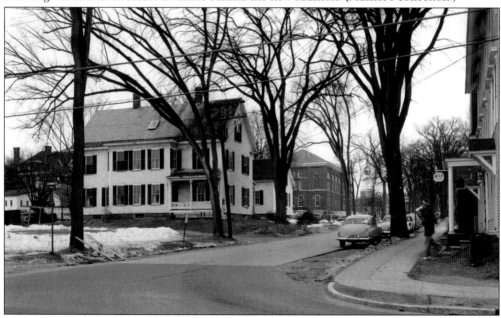

At one time, College Street ran south and connected with Lebanon Street. This 1956 photograph looks up the street from the intersection of Lebanon Street. At the immediate right is the old Kibling property that was acquired by the college in 1922. It was used as a dormitory until it was razed in 1959 as part of the Hopkins Center redevelopment project. Most of the buildings in this view were torn down at that time. (Dartmouth College Special Collections.)

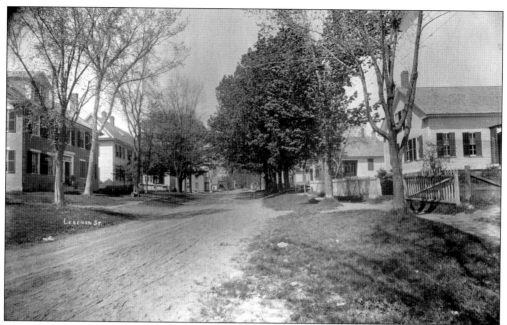

This is Lebanon Street looking west toward Main Street from about the intersection of Crosby Street about 1890. To the left is the brick house still standing at 25 Lebanon Street, constructed about 1840 by Methodist minister John Williams. (Dartmouth College Special Collections.)

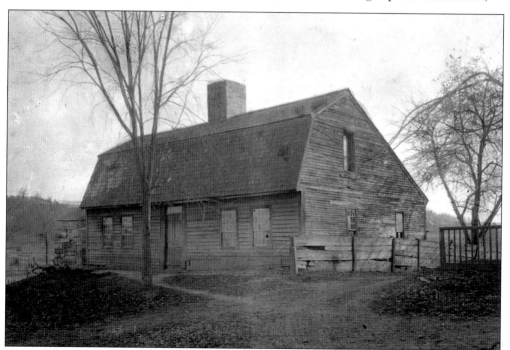

One of the earliest houses in the village area was this gambrel-roofed farmhouse erected sometime before 1774. Situated on the east side at about 27 Lebanon Street, by the late 19th century, the old dwelling had gradually fallen into disrepair and was subsequently torn down in 1894. (Dartmouth College Special Collections.)

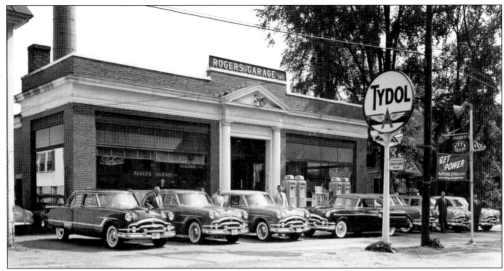

The new 1953 Packards are in and F. Manning Moody (left) and his sales staff at Roger's Garage await the buying public. The business was first established as a Reo dealership about 1908 by Samuel C. Rogers, Dartmouth's chief engineer and Moody's father-in-law. In 1931, a handsome, new showroom was constructed on the north side of Lebanon Street. It was razed in 1966. To the left, a corner of South Hall can be seen, and to the rear is the high smokestack of the college's central heating plant. (Author's collection.)

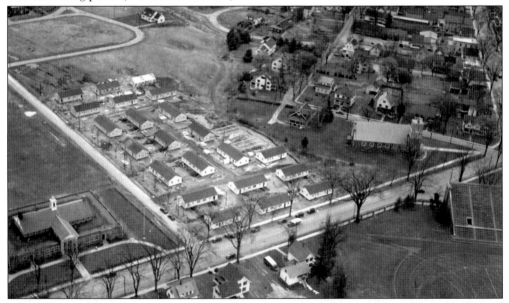

During the early 1940s, on the eve of World War II, government housing was quickly erected on the south side of Lebanon Street, beside the new grade school constructed in 1924. After the restoration of peace, the college acquired the complex, and in 1946, named it Sachem Village—housing for married students attending Dartmouth. By 1958, as a result of needing more units, the buildings were relocated to Gould Road in West Lebanon; and the land was turned over to the Hanover School District as new playground space. This view looks southwest. In the foreground is Lebanon Street, to the left is the school, and to the right is St. Denis Roman Catholic Church—constructed in 1923–1924. (Dartmouth College Special Collections.)

From a vantage point about opposite the Lebanon Street intersection, this 1876 view looks along the lower east side of South Main Street. The first two dwellings, the Tenney-Storrs house (1835–1929) and the Wainwright-Heneage house (1786–1965), are today the site of the post office building. (Author's collection.)

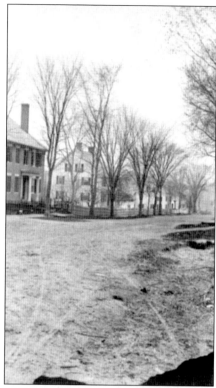

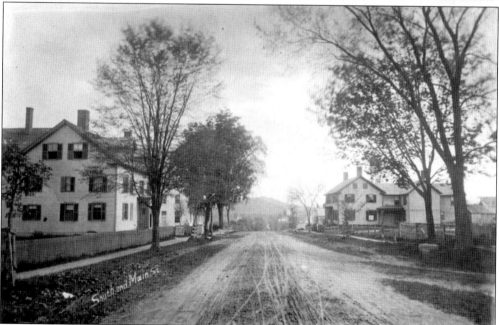

The Wainwright-Heneage house, believed to have been erected about 1786 by Lt. Benjamin Coult, is on the left in this 1890 photograph that looks south. Note the open space to the right of South Main Street, the result of the complete burning of Lower Hotel, or South Hall in 1888. (Author's collection.)

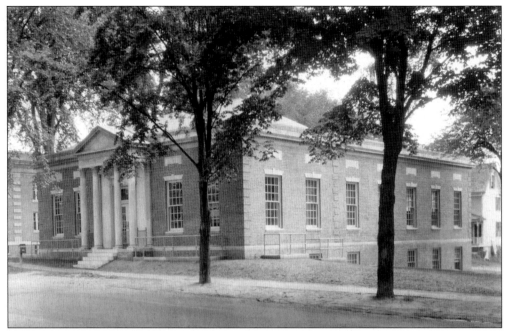

Until constructing a building specifically for its own use, the postal service was always a tenant at numerous locations within the village. In 1928, the federal government purchased the Tenney-Storrs house from Adna D. (Dave) Storrs, owner of the Dartmouth Bookstore. In 1931, work was finished on a new post office, shown here. (Author's collection.)

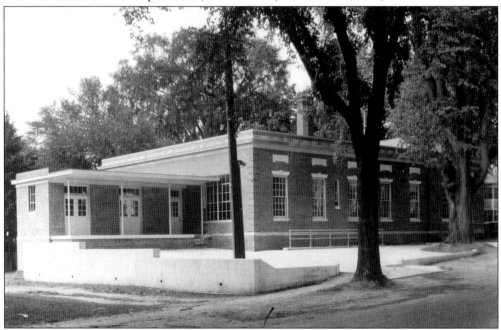

Hanover's new post office was modern in every way, including loading docks on the Lebanon Street side for motorized mail delivery trucks that were becoming common by the 1920s. In 1965 when the building was enlarged, this area was altered. Note the abundance of elm trees. (Author's collection.)

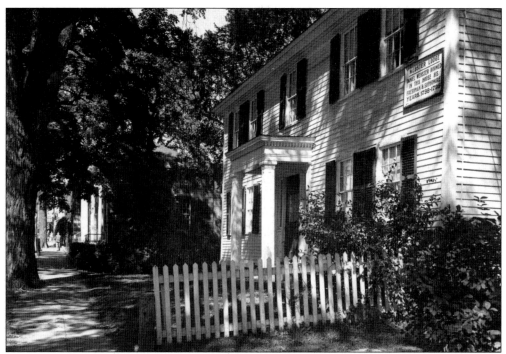

Well into the 20th century, the lower end of South Main Street retained its residential character, as noted in this 1954 frontal view of the Wainwright-Heneage house. The post office is shown beyond. Later research established that Daniel Webster did not room here, as the sign mistakenly indicates. The house was demolished in April 1965 to allow construction of a 52-by-60-foot addition to the post office. (Dartmouth College Special Collections.)

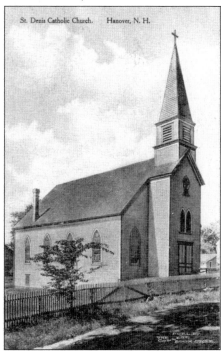

The first permanent home of the Catholic Church in Hanover was this building erected by them at 52 South Street, completed in December 1887. Later, after moving to their present St. Denis facility constructed on Lebanon Street in 1924, the old building was sold and converted into an apartment house. In 2006, the building was razed as part of Dartmouth's South Block redevelopment project. (Author's collection.)

Similar to the photograph on page 91, this 1890 view shows the Wainwright-Heneage house (1786–1965) on the left, the Gates house (1785–2007) that was moved to this site in 1884, and the Anthony Morse house (1823–2007). At right is the house erected by tailor George Walton about 1788. Today it is the location of a gas station and convenience store. (Dartmouth College Special Collections.)

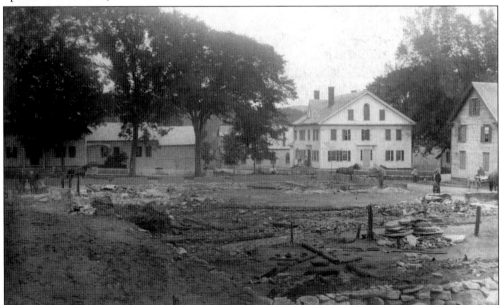

After the Lower Hotel or South Hall burned on July 11, 1888, along with two adjacent houses, the view looking east across South Main Street toward the Gates house was indeed quite open. In 1894, village entrepreneur Dorrance B. Currier erected a new commercial structure on this site. Today it is the location of the Fleet Bank building. (Dartmouth College Special Collections.)

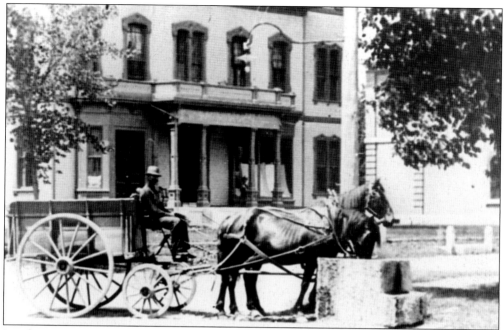

Until automobiles became more common, there was a horse watering trough located at the Main and Wheelock Street intersection on the corner of the green for many years. Carved from a single block of granite, it also featured a lower trough for the village's dogs. In the background is A. P. Balch's mansion, known as "the golden corner." (Author's collection.)

In addition to his livery stable located on Allen Street, Hamilton T. "Hemp" Howe provided transportation between the railroad station immediately across the river in Lewiston and Main Street. This wintry view from about 1905 shows Howe's sled-type "bus" at the Hanover Inn corner. In the background is the present-day Casque and Gauntlet fraternity house. (Author's collection.)

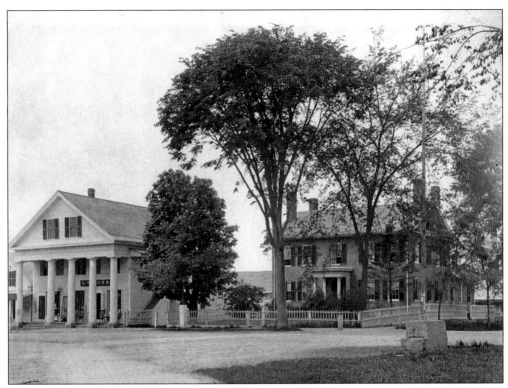

This is how the southwest corner of the South Main and Wheelock Street intersection looked about 1870. To the right is Dr. Samuel Alden's brick house, constructed in 1823. Beside that is Cobb's Store, erected in 1793 by Rufus Graves. In the foreground is the combination horse-and-dog watering trough mentioned on page 95. (Dartmouth College Special Collections.)

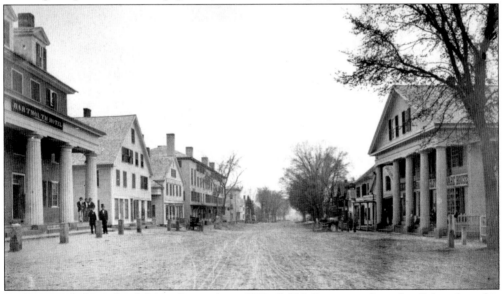

Looking south down South Main Street about 1870, Cobb's Store is to the right. Other than this large building, until the late 19th century, the opposite side of Main Street housed the majority of the village's businesses. (Dartmouth College Special Collections.)

The first two-story construction in the village area was built as a tavern in 1771 by Aaron Storrs on the site of the front lawn of Dr. Samuel Alden's brick house. When Alden completed his new home in 1823, he simply moved his belongings out the back door of the old building and in through the front door of his new residence. He then moved the old house onto his garden at 6 West Wheelock Street (see page 101). (Author's collection.)

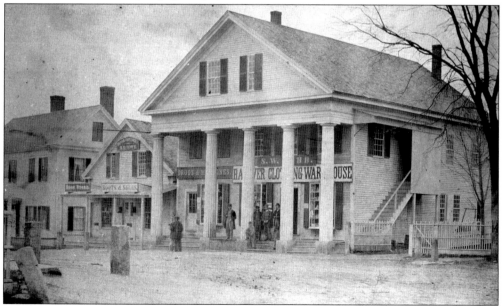

Rufus Graves, a young Dartmouth graduate of great energy and enterprise, erected this large two-story commercial building in 1793. Originally it was constructed without the gable and colonnade but rather with a hipped roof. Graves had a mercantile operation on the first floor and a spacious, open rental hall on the second floor. Here is the building with Cobb's Store about 1860, in perhaps the earliest-known photograph of Main Street. (Author's collection.)

The first movie house in Hanover was the Nugget Theater, a simple, metal building quickly put up at 2 West Wheelock Street by Main Street businessman Frank W. Davison in 1916. By 1922, the theater came under the management of the newly formed Hanover Improvement Society that extensively remodeled and enlarged the facility in 1927, as shown in this view. (Author's collection.)

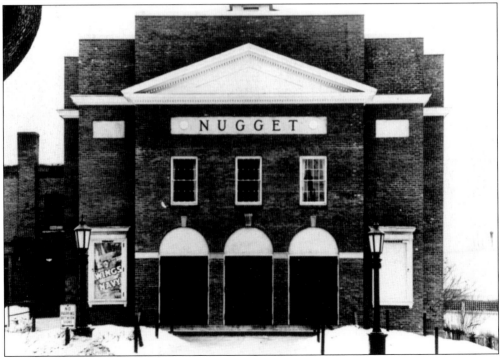

In 1938, the moneymaking Nugget Theater building was once again remodeled and enlarged by the Hanover Improvement Society to a new capacity of 860 seats. Its popularity with Dartmouth College students seemed to know no bounds. (Author's collection.)

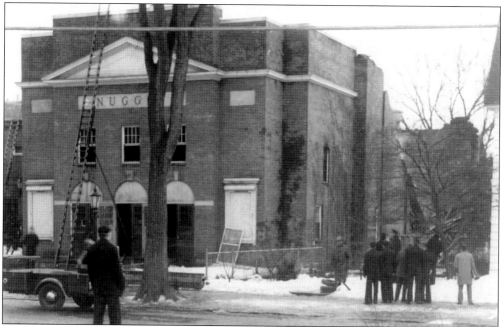

During the early morning hours of January 28, 1944, a fire followed by an explosion, both of unknown origins, destroyed all but the front lobby portion of the building. Until it was torn down for the Banwell building in 1970, the remaining lobby area became a Western Union office, and for a time, movies were shown in the college's Webster Hall. (Author's collection.)

In the fall of 1838, the college sold the old Eleazar Wheelock house (see page 21), and it was moved to 4 West Wheelock Street. This 1875 view of West Wheelock Street shows the brick el of the Alden house (1823), the Wheelock house (1773), and the Storrs-Alden house, which was built in 1771 and relocated in 1823. The pile of timbers beside the street is probably a result of St. Thomas's church being under construction. (Dartmouth College Special Collections.)

From 1846 through the 1850s, A. P. Balch made numerous alterations to his original house, including reconstructing the upper roof steeper and adding other early Victorian embellishments. In the 1880s, others added the bay windows. The rear stables eventually became part of the Inn Garage on Allen Street. (Author's collection.)

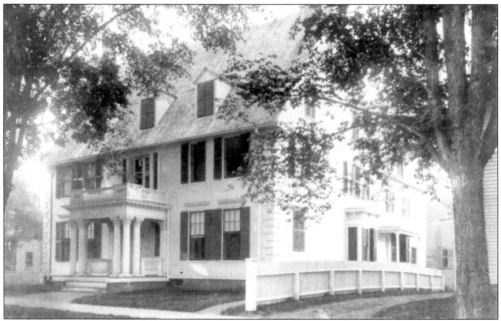

By 1884, the Wheelock house was owned by the Howe family, whose daughter Emily Hitchcock Howe gave the building to the community for use as a library in 1900. Shortly after, the college's architect, Charles Alonso Rich, was enlisted to assist with some restoration work on the building; and in 1915, new masonry stacks were added to the rear of the building, replacing the el and stables seen here about 1910. (Author's collection.)

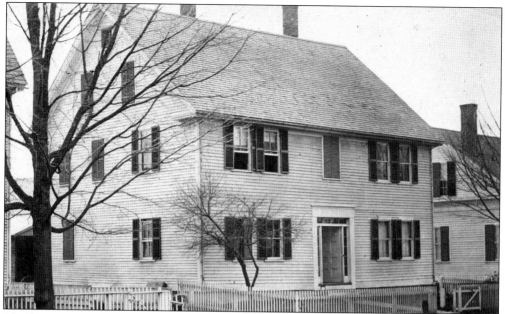

The first two-story frame house erected in the village was this building, operated as a tavern by Aaron Storrs from Lebanon, Connecticut. Originally on the site of the Casque and Gauntlet house (see page 95), the building was moved in 1823 to 6 West Wheelock Street. By 1909, it became the home of the Delta Kappa Epsilon fraternity and was razed for a parking lot about 1968. (Dartmouth College Special Collections.)

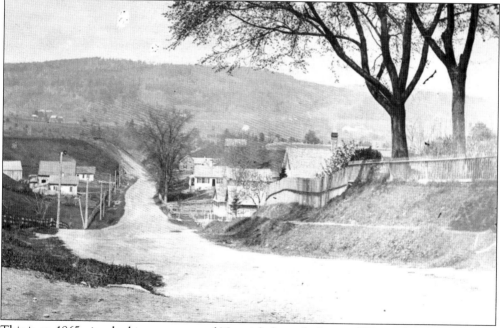

This is an 1865 view looking west toward Norwich from the brow of West Wheelock Street, or "River Street," as it was then unofficially called. The steep grade down to the river was often referred to as "Depot Hill" after the railroad came through the valley in 1848 and established a depot across the bridge in Lewiston. (Author's collection.)

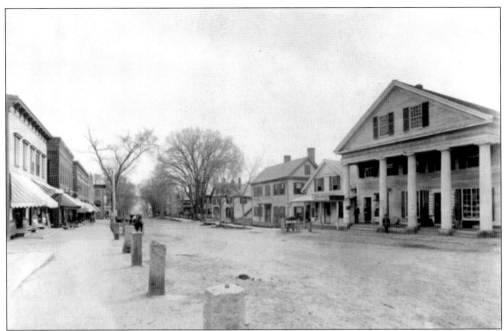

This image of the upper west side of South Main Street from about 1890, illustrates that, other than the large commercial building erected by Rufus Graves in 1793, this area remained primarily residential in scale and character until very late in the 19th century. (Dartmouth College Special Collections.)

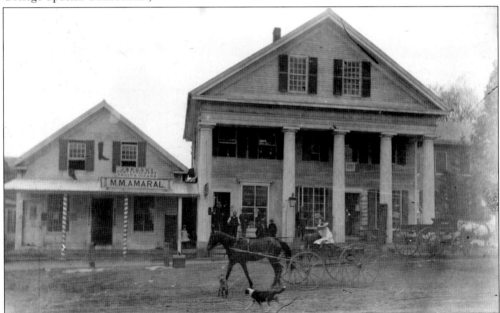

Local history did not record when Deacon Sylvester Morris of Norwich erected the building immediately south of Graves's imposing structure; however, for many years it housed his shoe store, the post office, and M. M. Amarall's barbershop. The building was later moved to the rear of the lot in 1893 when the first half of the Davison block was constructed. (Dartmouth College Special Collections.)

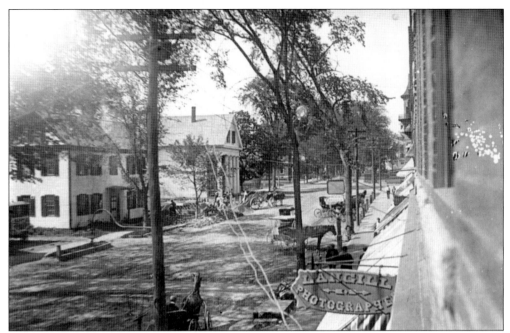

In 1893, after removal of the small, one-and-a-half-story wood frame building, Hanover merchant Frank W. Davison began construction of the first half of the three-story brick Davison block. This photograph, taken from the second-floor window of Langill's Photographic Studio, looks north across the street at the start of construction. (Author's collection.)

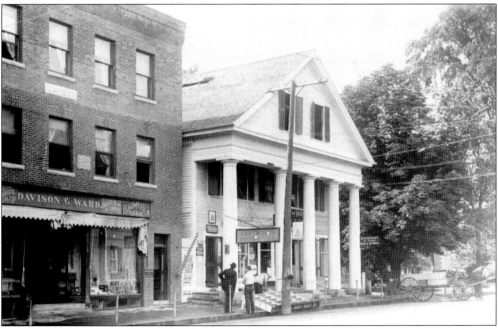

When completed, the new brick block housed the grain, grocery, and hardware store of Davison and Ward and apartment space above. To the right is the old Graves-Cobb's store building, in which the Dartmouth Bookstore was the principle tenant. It was razed in 1903. Note the newly paved street in this 1902 view. (Author's collection.)

The present-day site of the three-story Bridgman block was originally the location of three smaller wood frame residential and shop buildings and a large livery stable operation in the rear. This late-19th-century view shows the southernmost shop building, erected in 1829 by Jabez A. Douglass. A second duplicate shop building was moved away in the 1870s and relocated to 3 Pleasant Street. (Author's collection.)

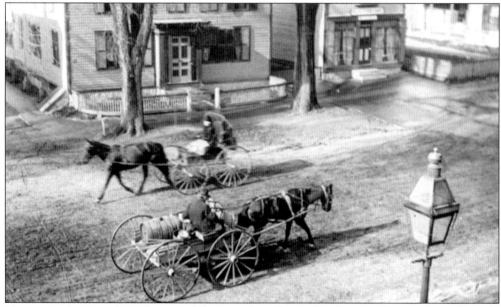

Here is another view from the second-floor window of Langill's Photographic Studio in the early 1890s. It looks across to the west side of the street and shows the 1829 Douglass shop building mentioned above and the Young-Walker house (1780–1930). For more information, see page 109. (Author's collection.)

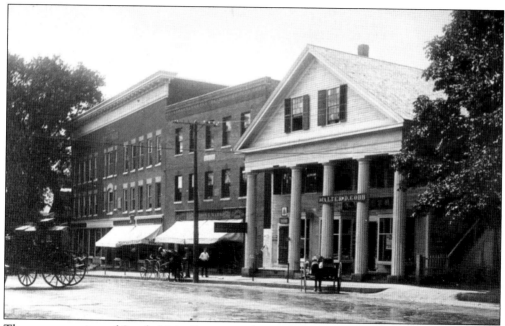

The upper portion of South Main Street was first paved in 1901, the same year that the first automobile was seen in the village. A year earlier, Don S. Bridgman constructed the first Bridgman building (left), and two years later in 1903, Frank W. Davison constructed the second half of the Davison block (right). (Author's collection.)

As the Main Street continued to evolve, if older buildings did not fall victim to accidental fire, in many cases, they were simply moved to the rear of the lot and used for storage. Such was the case of the 1829 Douglass shop building, seen here about 1965 from an upper back porch of the Bridgman building. About 1967, the antique building was torn down. (Author's collection.)

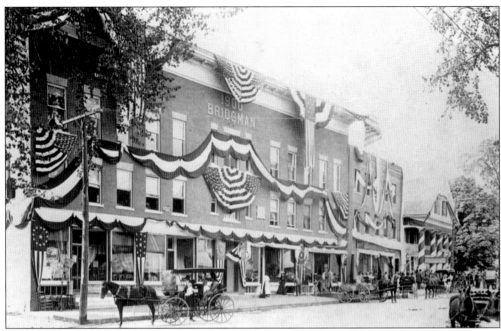

Don S. Bridgman, who was from a prominent early Hanover family and served as one of three town selectman from 1890 through 1922, constructed this impressive new commercial block in 1900, replacing the old wood frame buildings seen on page 102. This image, taken in 1902, shows the building decorated for the Fourth of July holiday. (Author's collection.)

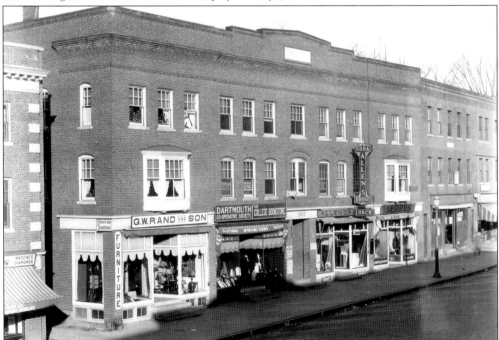

During the night of October 30, 1906, the Bridgman block completely burned and was fully rebuilt by a new structure the following year. It is seen here around 1940. To the left is a corner of the Gitsis building, constructed in 1930. The Davison block is to the right. (Author's collection.)

Once considered to be one of the busiest barbershops in the state, Walt and Ernie's has been located in the Davison building annex since the mid-1930s and has long been a Hanover institution. Started in 1903 by Walter Chase and Ernie Desroche and located in the Hanover Inn lobby, by the 1970s, it was owned by Carley Massey, who is seen here in the background. By the early 1980s, the shop was owned by Bob Trottier, an employee since 1957. (Author's collection.)

Pasquale "Serry" Serafini was originally from the ancient village of Atessa, Italy, and came to Hanover through Philadelphia along with a Russian tailor named Jacob Omelchenko. In 1907, they opened Serry's, a men's clothing and tailor shop located in the Bridgman building. Frank, Sam, and Dom Zappala purchased the business in 1954, and in 1985, the store moved to Lebanon Street. Serafini died in Hanover in 1960 at age 81. (Author's collection.)

Adna D. (Dave) Storrs, a direct descendant of Hanover's earliest settlers, owned the Dartmouth Bookstore from 1916 until his death in 1953. His father, Edward Payson "E. P." Storrs, had acquired the store in 1884 from graduating Dartmouth student Nelson McClary. Both Dave and his father were very active in many aspects of community business, and civic and governmental affairs throughout their long lives. (Author's collection.)

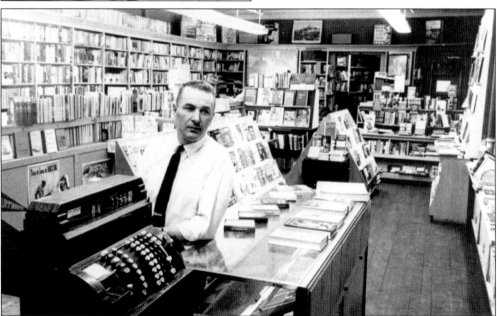

Wilber (Wil) Goodhue came to work for Dave Storrs at the Dartmouth Bookstore upon graduating from high school in 1938. After serving in the military during World War II, he returned to the store and became manager upon the death of Storrs. In 1963, he moved the store from the Davison block to its present location in the Gitsis building. After further expanding the business, he retired in 1976. (Author's collection.)

John Young, married to Eleazar Wheelock's daughter Theodora, erected this house about 1780; however, for many years, it was owned by William Walker and thereafter referred to as such. In 1906, the village precinct acquired it for municipal offices and fire department use. In 1929, George Gitsis purchased the building for his restaurant; however, the building burned in 1930. It was replaced by the present Gitsis building that same year. (Author's collection.)

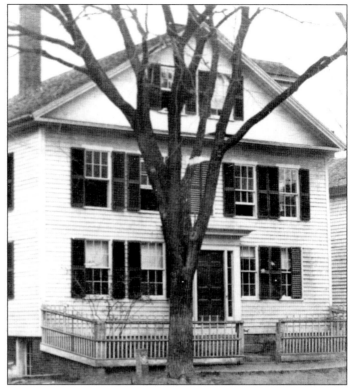

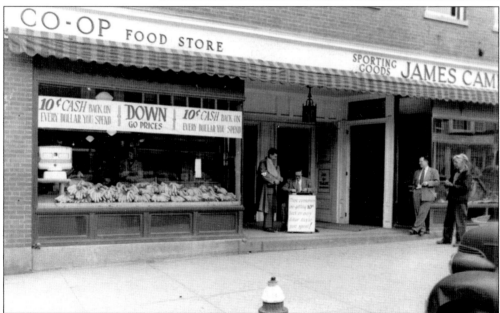

Organized in 1936 and first operating out of a member's garage, the Hanover Consumer Coop was the principle tenant in the Gitsis building from 1942 until moving into its new store at South Park Street in 1963. In June of that year, the Dartmouth Bookstore relocated from the corner of the Davison block into the first-floor space that had originally been George Gitsis's Campus Café restaurant. (Author's collection.)

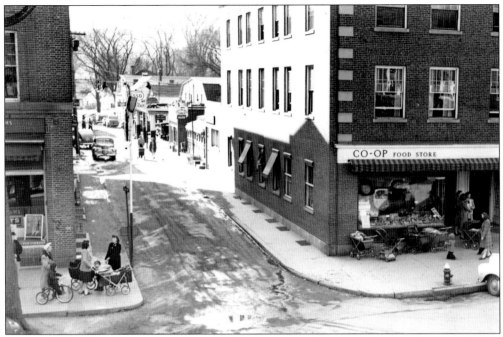

David L. Pierce took this photograph looking west along Allen Street from the second floor of his photography studio in 1948. To the right is the Gitsis building; and to the left is the Musgrove building. On Allen Street a small diner can be seen, and just beyond that is the Inn Garage. (Dartmouth College Special Collections.)

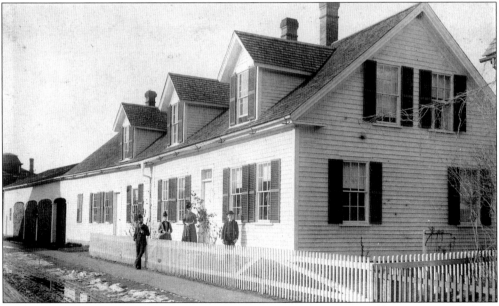

Early property records indicate that this house, originally located at 5 Allen Street, might have been built about 1796. In 1922, when Frank Tenney constructed the new garage facility shown on the following page, he relocated the house farther down to 17 Allen Street, where it still stands today. This photograph was perhaps taken about 1880 and possibly shows the Allen family standing out front. (Sam Zappala.)

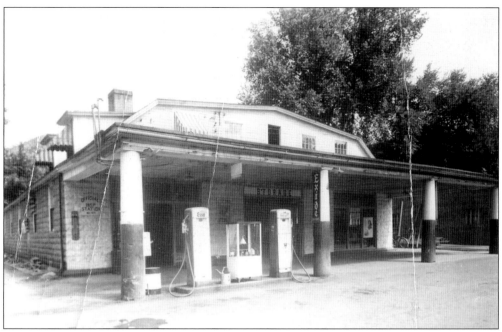

In 1922, livery stable operators Charles Nash and Frank Tenney constructed this facility on the north side of Allen Street to fuel, service, and store automobiles. After numerous alterations over the years, it is today occupied by EBA's Restaurant and the Dartmouth Bookstore. This image shows the building in the 1940s. (Author's collection.)

From 1945 until closing the business in 1978, Raymond P. Buskey operated the Inn Garage at 7 Allen Street. This late-1960s promotional photograph shows Buskey and mechanic Andrew A. Morse. In the background is the 5 Allen Street building also illustrated at the top of this page. (Author's collection.)

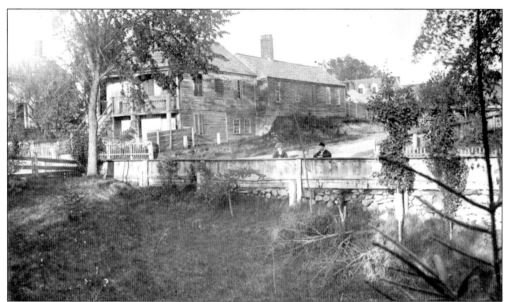

Allen Street, first partially opened in 1835, was extended through to School Street in 1869. The street was named for Ira Babcock Allen, an early stage driver, who for many years operated the Allen Livery Stable—one of four such businesses in the village during the 19th century. This image shows the Allen and School Street intersection about 1870. The building shown later became the Ashbel Hotel. (Author's collection.)

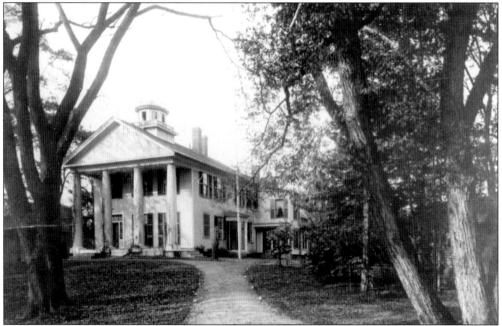

Very little is known of Stephen Brown, who erected this stately Greek Revival–style home at 9 School Street in 1835. When first occupied, this location was at the edge of the village area bordering on farmland. Still standing at its original location, since about 1902 it has been home to several college fraternities, and numerous additions and alterations have been made to the building as a result. (Author's collection.)

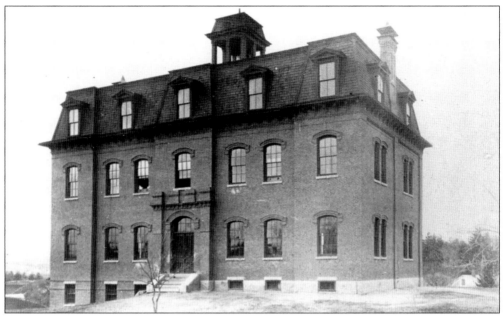

In 1877, Allen Street was extended west of School Street, and a new school facility was constructed on the north side of the extended street. Dartmouth professor of mathematics Frank A. Sherman designed the new building, and Mead, Mason, and Company of Lebanon constructed it at a final cost of $10,933.04. A classroom addition was constructed in 1896. The building was razed in 1937. (Author's collection.)

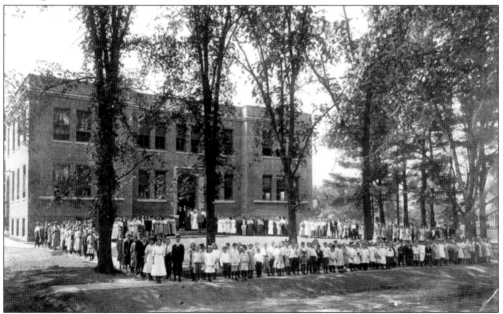

Although Hanover High School was established in 1888, it did not have a building separate from the lower grades until the construction of this new facility on the south side of Allen Street, located across from the older facility illustrated above. Designed by Boston architect E. J. Wilson, the new facility was constructed in 1912 by J. H. Davidson, also of Boston. The building was razed in 1937. (Author's collection.)

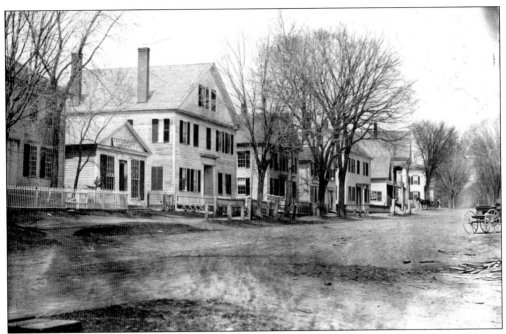

This very early photograph from about 1860 looks north along the west side of South Main Street from about the Lebanon Street intersection. The first two structures occupy the site of the present-day municipal building. The large house in the foreground is on the current site of the Musgrove building. (Dartmouth College Special Collections.)

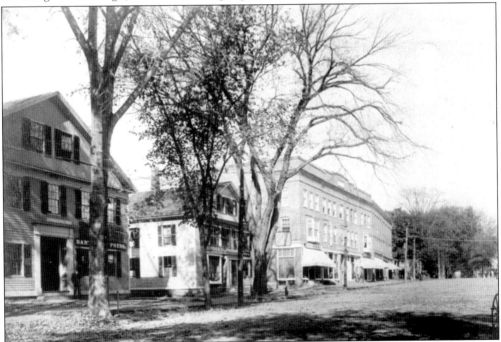

This photograph is similar to the view above, but it was taken about 50 years later around 1910. Clearly illustrated is the evolutionary progress of the built environment advancing down the west side of South Main Street. (Author's collection.)

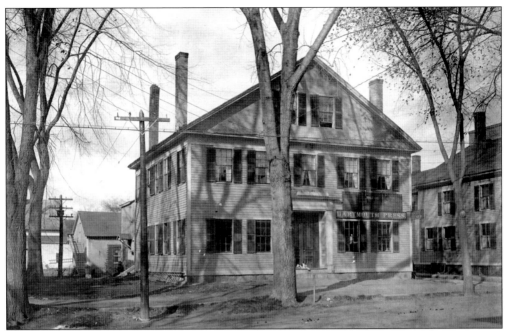

Abraham Dunklee, a shoemaker, erected this home probably about 1820, although records do not exist to confirm this. Frank A. Musgrove, a recent Dartmouth graduate, acquired the property in 1899 to house his business, the *Dartmouth Press*. The building burned on the night of May 3, 1914. (Author's collection.)

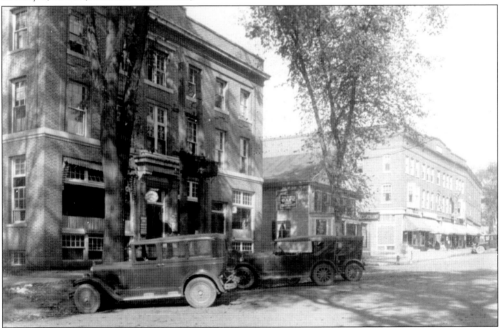

Within a year of the old house's destruction by fire, Musgrove had a new and substantial structure constructed of masonry, steel, and poured concrete that housed both his printing business and the U.S. post office. This image, looking up the street, shows the building in 1929 and George Gitsis's Campus Café in the old Walker house beyond it. (Author's collection.)

In 1869, the Episcopal Church moved two old buildings (seen on page 114)—a two-story house erected about 1780 by Prof. John Smith and a small shop building of unknown origin. That year, a new rectory was built, and two years later in 1871, the little chapel on the south side was erected. (Author's collection.)

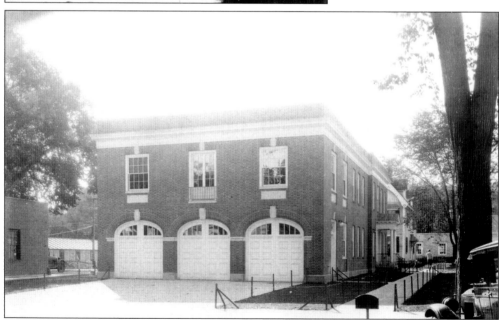

By the 1920s, Hanover was in need of space for municipal, court, fire, and police department use. As a result, in 1928 the old rectory building was moved back from the street, and a new municipal building costing $50,611.09 was constructed by W. H. Trumbull from plans prepared by Larson and Wells architects. It is shown here at completion. Note the old house beyond, razed in 1959. (Author's collection.)

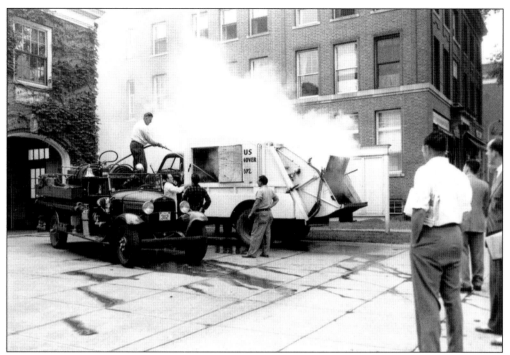

Richard "Duke" LaBombard did not need to travel far when he realized that he had a fire burning inside the rear compactor body of his new Chevrolet trash truck; he just drove to the fire station on Main Street. In the background of this 1955 view is the Musgrove building. (Author's collection.)

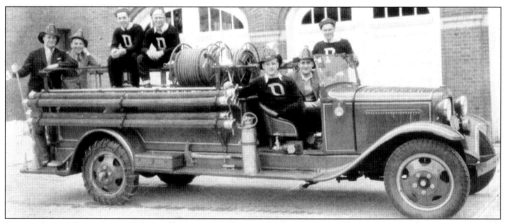

Since the earliest days of the college and village cohabitating on the Hanover plain, Dartmouth students have been an important component of fire protection; they often made the critical difference in situations like the "great Lebanon Street fire of 1883" (see page 87). Here are Dartmouth College student members of the Hanover Volunteer Fire Department with the village's new 1931 Ford Model AA fire truck. (Author's collection.)

This wintry scene is the west side of lower South Main Street looking south from about opposite Allen Street around 1860. The small shop building and the two-story house beside it to the south also appear in the upper photograph on page 114. Both of these buildings were on the site of the present-day municipal building. (Dartmouth College Special Collections.)

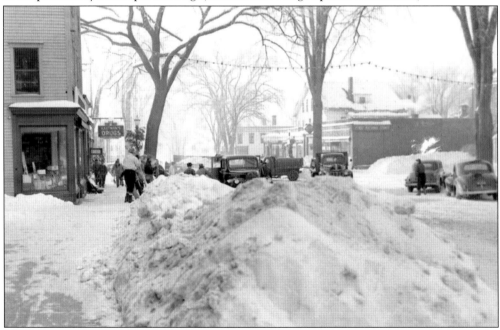

This late-1940s view looks across South Main Street from about the same vantage point as the image above after a substantial snowfall. The Bishop block, built about 1925 next to the municipal building, housed a First National brand grocery store in the front and a Railway Express Agency office in the rear. Today this is the location of Molly's Restaurant. (Author's collection.)

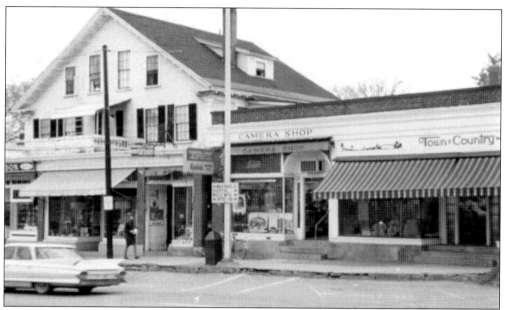

This large, wood frame house, also shown on page 84, was erected by Alfred Morse about 1842. Around 1922, a low, single-story "tax payer" commercial addition was constructed on the front of the old house. The Bishop block beside it was probably constructed about 1925. (Author's collection.)

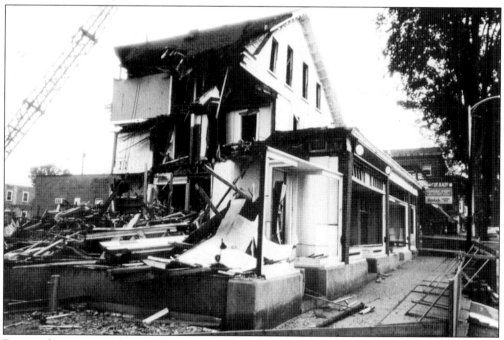

During the summer of 1969, the Hanover Improvement Society had the old Morse house razed in preparation for construction of the Nugget Arcade building, which was completed the following summer. The new retail and office facility was constructed by the Trumbull-Nelson Construction Company and was designed by the author's father, architect Frank J. Barrett. (Author's collection.)

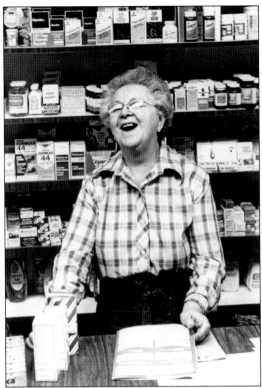

In 1939, George and Clara Sauter opened a store, Edith Cut Rate, on Main Street that was a local institution for generations of young Dartmouth men. They named the store for their daughter Edith. It was located within the storefront addition of the old Morse house next to the Bishop block and the Reub's Camera Shop. (Author's collection.)

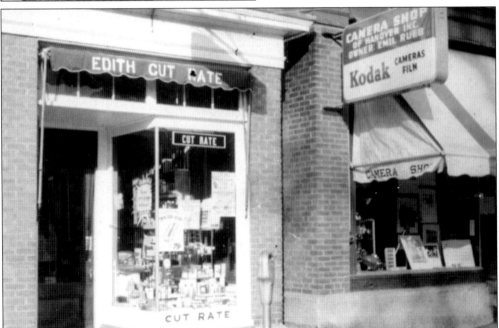

After George's death in 1954, Clara maintained the store until the building was razed for the new Nugget Arcade in 1969. A year later when the new building was completed, Clara surprised many by unexpectedly reopening the store, and she continued running it until finally retiring in 1989. Born in eastern Europe in 1898, she died in Hanover in 1994. (Author's collection.)

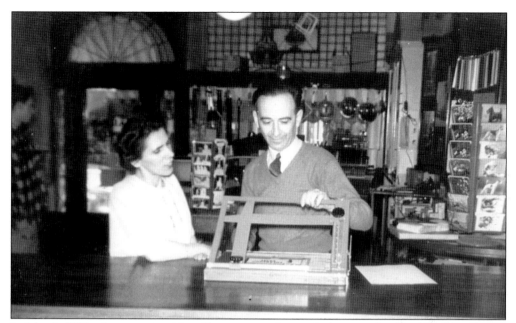

In March 1939, after escaping Nazi Germany, professional photographer Emil Reub settled in Hanover and purchased the camera shop from former owners Philip and Paul Carter. In 1946 after World War II ended, he was finally joined by his fiancée Elisabeth Bickel. Together they ran the business first located in the Bishop block and later in the Nugget Arcade. This photograph was taken about 1947. (Author's collection.)

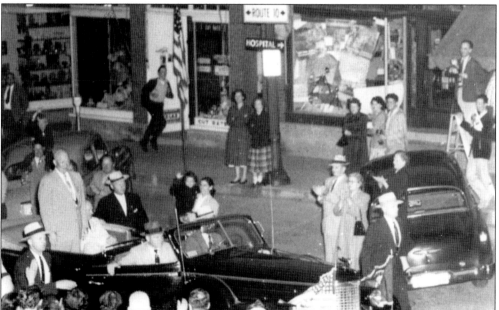

On June 14, 1953, recently inaugurated Pres. Dwight D. Eisenhower attended commencement exercises at Dartmouth College, where he gave a brief but noted address and received an honorary degree. Here his motorcade is approaching the campus from South Main Street, having started at the airport in West Lebanon. In the background are Edith Cut Rate and the camera shop. (Author's collection.)

From the Lebanon Street intersection, this view looks southwest on South Main Street about 1870. To the left is the Tenney-Storrs house (1835–1929), also shown on page 83. To the right on the west side of the street is the Lower Hotel (1790–1888), which was later owned by the college and used as a dormitory until burning in 1888. Today the Fleet Bank building is on that site. (Author's collection.)

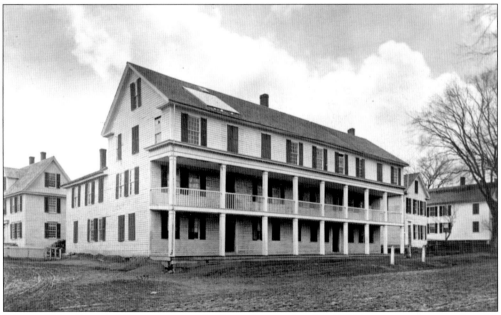

About 1790, Gamaliel Loomis erected a large house that by 1802 became a tavern. For the next 86 years, alterations and enlargements were made under various ownerships and business names, including the Lower Hotel. By July 11, 1888, when the building burned, the property was a dormitory for the college known as South Hall. Both adjacent houses shown in this 1870 view were also destroyed in the fire. (Author's collection.)

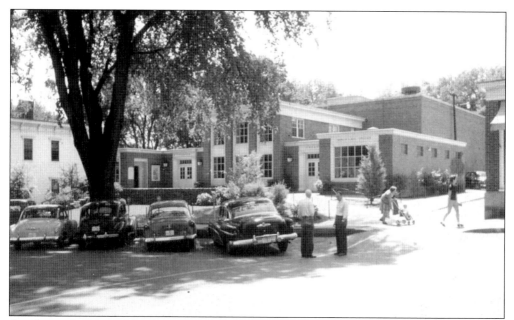

On September 23, 1951, the Hanover Improvement Society opened its newly constructed state-of-the-art Nugget Theater, a 900-seat movie house, to replace the old facility destroyed by fire on January 28, 1944 (see page 99). The new building was designed by architects Orcutt and Marston and constructed by the Trumbull-Nelson Construction Company. Two houses on the site built in 1836 and 1889 were razed for the construction of the theater. (Author's collection.)

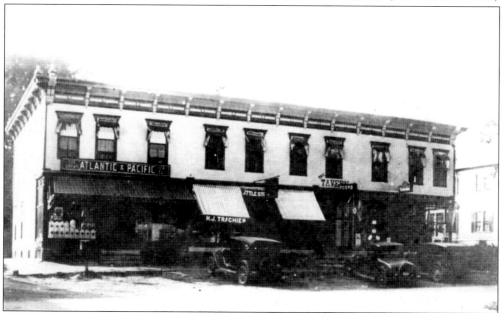

For six years after the old Lower Hotel burned in 1888, the lot sat vacant until local businessman and entrepreneur Dorrance B. Currier erected the new so-called Tavern block, seen in this 1920s photograph. The building proved relatively short-lived; by 1957, it was razed for a municipal parking lot. In 1974, the current bank building was constructed on the site of the parking lot. (Author's collection.)

Gulf Oil Company acquired the property of Nellie E. Newton in 1936 that included the house erected by George Walton about 1788 (see page 94). After clearing the site, Gulf constructed a large brick service station, repair, and automobile storage facility, shown here around 1960. (Author's collection.)

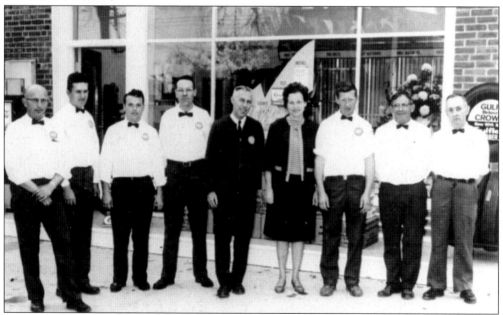

By 1963, the large facility illustrated above was no longer required and was replaced with a smaller, more efficient building. This picture, taken on opening day in 1963, shows the staff of Manchester's Gulf station. Jack Manchester, seen in the center of the photograph, came to Hanover in 1942 from the Boston area to manage the business for Gulf Oil. Today it is a convenience store with gas pumps. (Author's collection.)

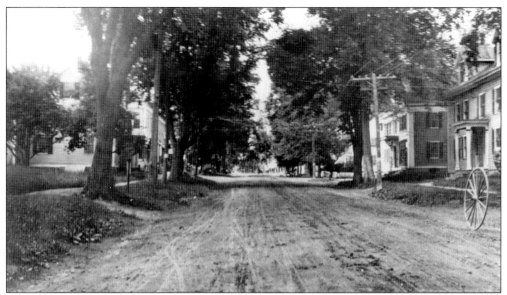

This photograph shows South Main Street about 1900, looking north from opposite the present-day intersection of Dorrance Place. At the right are the Morse (1823–2007) and Gates (1785–2007) houses. Barely visible at the left beyond the trees is the Tavern block. (Author's collection.)

Another view looking north on South Main Street about 1900 was taken from the brow of the hill. At left is a house that was built by Thomas D. Carpenter in 1825 and razed about 1960. The site is today the parking lot of the CVS store. On the right is Dorrance B. Currier's far house that was erected about 1850 by his father, Jonathan G. Currier, and enlarged in 1869. (Dartmouth College Special Collections.)

By the 1960s, Dorrance B. Currier's farmhouse had become the Green Lantern Inn and was under the ownership of Al and Kitty Lauziere of Hanover. In 1973, the building was razed for the Hanover Bank and Trust. Today the Galleria building, constructed in 1985, is on the site. (Dartmouth College Special Collections.)

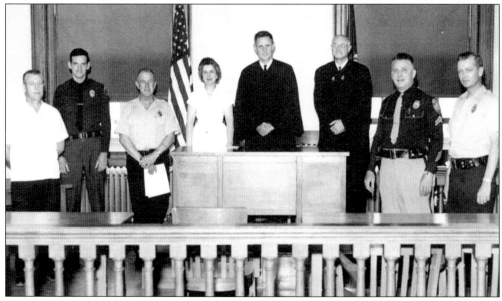

A July 1964 session of the Hanover District Court, located on the second floor of the municipal building, is about to get under way. From left to right are Orford police chief Ralph Mack; New Hampshire Fish and Game officer Dick Bryant; Hanover police chief Dennis Cooney; clerk Lillian LaBombard; Judge S. John Stebbins; Associate Judge Herbert W. Hill; New Hampshire State Police corporal Harold M. Morse; and Hanover patrolman Ben Thompson. (Author's collection.)

For many years, an annual event was the Christmas Eve party in Tony Cacioppo's basement, usually attended by a good cross section of Main Street personalities. Seen here in 1944, clockwise from the left side of the table are Harry Tanzi, Cacioppo, Bob Bannon, Ernest Zappala, Ray Buskey, Dick Rand, and John Tanzi. (Author's collection.)

ACROSS AMERICA, PEOPLE ARE DISCOVERING
SOMETHING WONDERFUL. THEIR HERITAGE.

Arcadia Publishing is the leading local history publisher in the United States. With more than 3,000 titles in print and hundreds of new titles released every year, Arcadia has extensive specialized experience chronicling the history of communities and celebrating America's hidden stories, bringing to life the people, places, and events from the past. To discover the history of other communities across the nation, please visit:

www.arcadiapublishing.com

Customized search tools allow you to find regional history books about the town where you grew up, the cities where your friends and family live, the town where your parents met, or even that retirement spot you've been dreaming about.